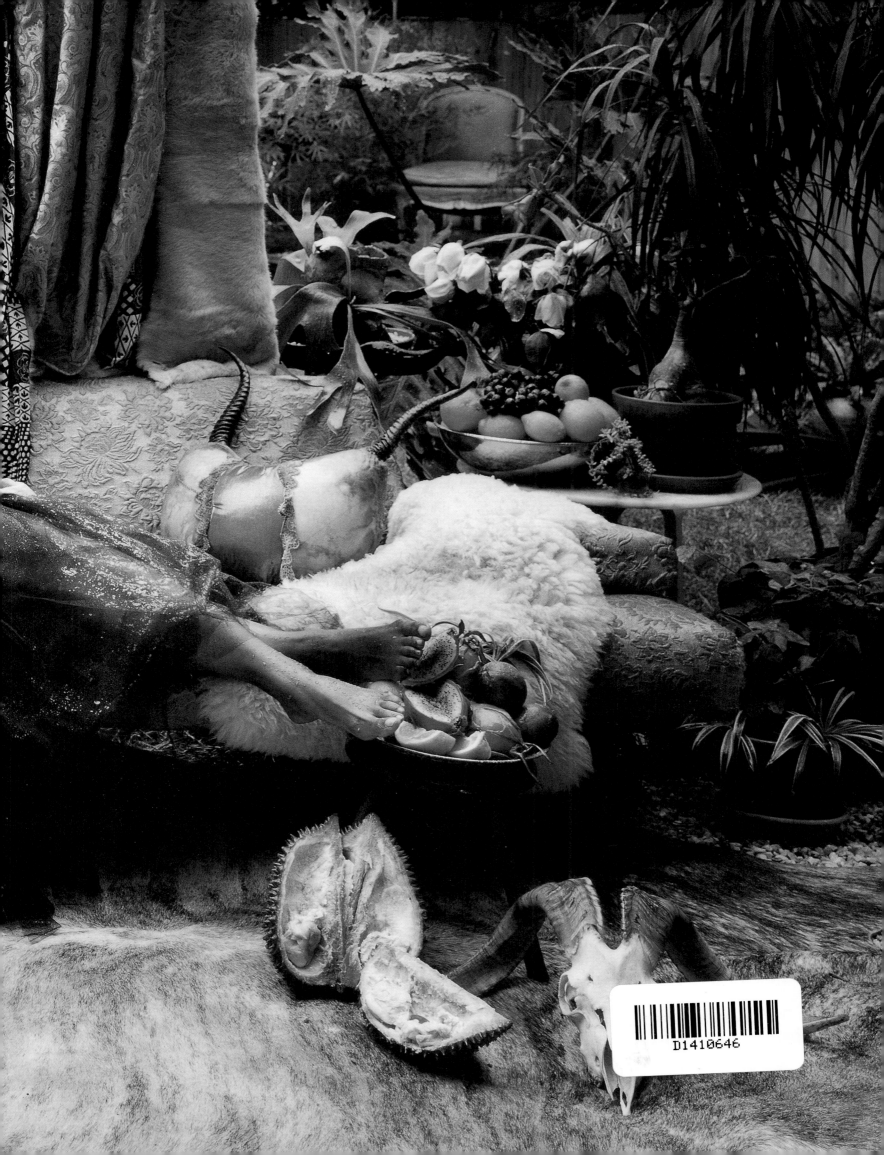

WANGECHI MUTU
A SHADY PROMISE

WANGECHI MUTU
A SHADY PROMISE

[DAMIANI]

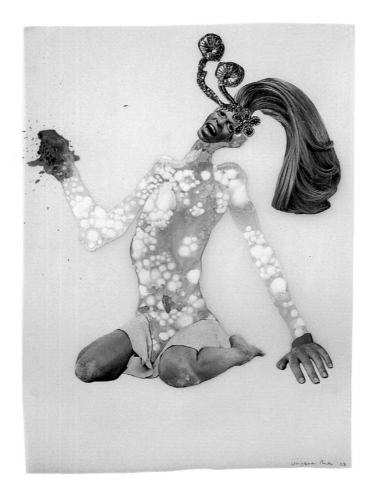

Wangechi Mutu, *A Shady Promise*

© Damiani 2008
© works, Wangechi Mutu
© all the authors for the texts
© photo credits:
page 78, Rebecca Stewarts
pages 123-125, Erma Estwick; *pages 126-129* Todd Johnson;
pages 130-132, Daniel Mirer; *pages 135-136*, Ben Dashwood;
pages 138 & 139, Wangechi Mutu; *pages 141 & 142*, Grant Leighton;
page 143 (top), Grant Leighton; *page 143*, Karen Del Aguila;
page 144, Karen Del Aguila; *endpapers*, Kathryn Parker Almanas

editor
Douglas Singleton

editorial coordination
Marcella Manni

Translation
Chiara Scardoni

design
Omnivore

[DAMIANI]

Damiani editore
via Zanardi, 376
40131 Bologna, Italy
t. +39 051 63 50 805
f. +39 051 63 47 188
info@damianieditore.it
www.damianieditore.com

ISBN 978 88 6208 021 7

Printed in April 2008 by Grafiche Damiani, Bologna, Italy.

cover image: Wangechi Mutu, *A Shady Promise*, 2006

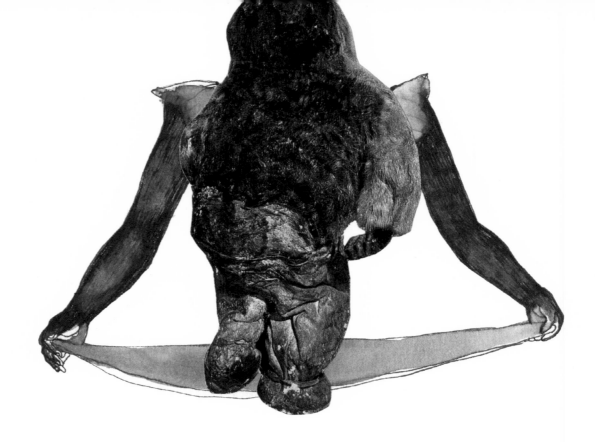

ENTER CAUTIOUSLY

Michael E. Veal

If Euro-America, under the weight of its own projected discourses, is able only to imagine the work of individual African artists as metaphor for nation, continent or race, the art of Wangechi Mutu seduces us brutally into the intricacies of the feminine as an embodiment of nation and continent, ultimately evolving into a cipher for a disfigured and evolving continent, planet and species. It down-ends the male-centered "big men" narratives of post-colonial Africa in favor of frightfully powerful animal-spirit women and their constituent body parts. Her work forces our collective engagement with the feminine form in its various conjugations of lover, giver and receptacle, but also as predator and merciless avenger.

If some of Wangechi's art abounds with collaged hot pinks, emerald greens, dandelion yellows, and implicitly feminized earth tones, these always and inevitably add up to something much more disturbing than their girlish hues and curly-cue trajectories initially seem to suggest. The finely worked images and surfaces betray an underlying agenda of inhabiting colonial tropes of Africa as site of sex, mysticism and unbridled nature (as well as contemporary tropes of Africa as diseased, blood-stained horror), in order to savagely subvert them. In some ways it's a blunt and brutal task, owing to the stubbornness of colonial constructs of race and culture. In other ways it's completely natural, for these very same reasons; the hard work of casting the black female body as fearsome spectacle has already been accomplished by centuries of colonial discourse. The artist has merely to agree to inhabit these discourses to begin her work. The aesthetics of black beauty, demonized almost beyond recognition through the prism of these discourses, are brutally confronted here, thrown back into the face of the viewer with a roots neo-psychedelic splendor. Straddling the symbiotic spheres of Africa and the West, Wangechi's ruminations assert the female figure as the most vulnerable receptacle of global forces, but reclaim territory by simultaneously casting woman as the most potent agent of regeneration.

At once primitivist and post-human, Wangechi's bodies and body parts are rarely merely human, save for the delicate black-and-white line drawings that open the book, tracing out the artist's youthful reveries of love, wonder, heartbreak, revelation and vulnerability. These delicate lines, skirting the tender treachery of adolescent awakening, frame the fundamentally terrifying questions that the rest of the book's images explode in graphic and certain terms.

Like an oasis of erotic beckoning carved out of dystopic, Double-XX African science fiction, the women featured in the *Pin-Up* series are mutants of a kind—survivors of all the violence and material/psychic toxins dumped upon their bodies and environs. Striking the alluring poses of skin magazine models, their animalistic, exaggerated features coyly invite the viewer to mount stumps, calluses, and bloodied scabs. Curvaceous, maimed beings, having just descended from trees, stare out at you with visages half-human, half-animal. The spectral, leggy leopard-hunter has decided that you're her next meal, as soon as she has digested the recently hunted ape-maiden slung across her shoulders. In what future, present or past world will these hairy pin-up babes—in their stained plantation finery and jungle garb—find their places in locker rooms, bathrooms, boardrooms, powder rooms, dormitories and prison cells? And in which genre will the film adaptation be categorized? Adult? Horror? Sci-fi? Fantasy? Or, as the elegantly serpentine arm in the final image suggests, in what religious iconography will they serve as devotional images?

The female forms in *Hybrid* series might be read as a commentary on sub-Saharan Africa as planetary site of the world's most vivid juxtapositions of the sublime and horrific, dousing caustic chemicals (or is that just melted strawberry ice cream?) upon characters that recall the Africanized syncopations of Romare Bearden's collaged bodies and ghettoscapes, the fantastical literary imaginings of Amos Tutuola, and the mutant 'hood societies of Pedro Bell. These women appear at times conjured from a fantastical realm of nocturnal toadstool reveries and at other times, fabricated from the rotting remains of open sewers, garbage heaps or toxic waste. Alternately engaging in mutual frolic or ecstatic disfiguration, their glorified orifices bestow life-giving fluids and anoint the land with toxic elixirs. It is ironic and telling, however, that a good portion of the oozing in Wangechi's art is not done via the usual body parts; rather, liquid pours as frequently from bodily punctures and ruptures. Which is to say, this is an ecstatic aesthetic of trauma. There is funky movement here for sure, but for the most part the movement and visages of these figures—alternately alluring or disconcerting—sublimate screams from within the tortured web of history.

The concluding series *Body As Space* organizes around two priorities. In the first part, the artist claims her fifteen minutes of digitally disfigured Afro-porn star fame. This is the body as pleasure center, elusively collaged with traditional African fabrics, a momentary respite from the thousand agonized ecstasies that have shaped the work thus far. The second half—more ritualistic, Catholic and sobering—presents a realm where supercalifragilistic angels cavort above fields of slaughter, skirting bullet-pocked walls to preside over a Catholic reviewing of stained, recovered garments and catalogued skeletons. Part sacrificial and part genocidal, the body is ritually re-spatialized here—reduced to one dimension, expanded to atmospheric proportions, brutally sliced, diced and punctured, liquefied into pools of blood awaiting our on-site touch and delectation. Finally—in the wake of slaughter—it degenerates back into the organic forms of the natural world. It's fitting that the collection ends with another, wall-sized orifice—promising the viewer yet more of such tender pleasures.

This is not a stereotypically African narrative of community. There is community here, to be sure, but it is largely a community of spirits and natural forces and the (usually) solitary humanoid mediums through which they erupt to dispense their wrathfully regenerative energies on a distorted world. As such, Wangechi's commentary on womanhood feels ultimately spiritual and alchemical in the sense that such a large part of her corpus is obsessed with transformation: forcing us to read the beauty in human disfiguration and fragmentation, as a mere transition to a different type of beauty, or a type of beauty in and of itself. It is also profoundly ecological, in the sense that her women are always intimately interfaced with the processes of nature. These heroines sprout and descend to seduce, spook, enchant and scare the hell out of the viewer, demanding new ideologies of ecological, erotic and romantic love to interpret their existence, and to demand justice and realignment.

Michael E. Veal, author of *Fela: The Life and Times of an African Musical Icon* (2000) and *Dub: Soundscapes and Shattered Songs in Jamaican Reggae* (2007).

ENTRARE CON PRUDENZA, INCREDIBILE

Michael E. Veal

Se l'Euro-America, sotto il peso dei propri discorsi prevedibili, è capace di immaginare il lavoro di singoli artisti africani solo come metafora di nazione, di continente o di razza, l'arte di Wangechi Mutu ci trascina violentemente nei grovigli del femminile come incarnazione del concetto di nazione e di continente che si fa infine simbolo di un continente, di un pianeta e di una specie metamorfici e deturpati. Periferizza le narrazioni maschiocentriche dei "big men" sull'Africa post-coloniale a favore di donne spaventosamente potenti dallo spirito animale e dei loro corpi. Il suo lavoro ci costringe ad un confronto collettivo con il femminile nelle sue varie coniugazioni di amante, datrice e ricettacolo, ma anche come predatrice e nemesi impietosa.

Se certa arte di Wangechi è fatta di un collage ricco di rosa caldi, verdi smeraldo, gialli tarassaco e dei colori della terra implicitamente femminilizzati, essi risultano sempre ed inevitabilmente in qualcosa che è ben più fastidioso di quanto sembrino inizialmente suggerire le tonalità da ragazzina e le linee arricciate. Le immagini e le superfici lavorate attentamente tradiscono una struttura programmatica sottostante abitata da tropi coloniali dell'Africa come luogo fatto di sesso, di misticismo e di natura incontrollata (non diversamente dai traslati contemporanei dell'Africa come orrore macchiato dalla malattia e dal sangue); struttura che tali tropi ha il preciso obiettivo di sovvertire spietatamente. Si tratta di un lavoro in qualche misura diretto e brutale, dovuto alla tenacia dei concetti coloniali di razza e di cultura. Per altri versi, ma proprio per queste stesse ragioni, è totalmente naturale; il duro compito di assegnare al corpo femminile nero un ruolo terrificante è stato già compiuto da secoli di discorso coloniale. Per iniziare la propria opera, all'artista non rimane quindi che accettare di abitare tali discorsi. L'estetica della bellezza nera, demonizzata al punto di diventare quasi irriconoscibile attraverso il prisma di questi discorsi, è qui affrontata con impeto e risbattuta in faccia allo spettatore con uno splendore neo-psichedelico delle origini. A cavallo tra le sfere simbiotiche dell'Africa e dell'Occidente, le riflessioni di Wangechi dichiarano la figura femminile come ricettacolo in assoluto più vulnerabile delle forze globali, ma allo stesso tempo rivendicano terreno, assegnando alla donna il ruolo di rappresentante più potente della rigenerazione.

Ad un tempo primordiali e post-umani, solo raramente i corpi e i pezzi di corpo di Wangechi sono semplicemente umani, tranne che per quei delicati e sottili disegni in bianco e nero che aprono il libro delineando le fantasticherie giovanili dell'artista sull'amore, la meraviglia, lo sgomento, la rivelazione e la vulnerabilità. Queste linee delicate, che eludono la perfidia del risveglio adolescenziale, fanno da cornice alle domande essenzialmente terrificanti che il resto delle immagini del libro demolisce graficamente e attraverso l'uso di certa terminologia.

Come un'oasi di richiamo erotico ricavata dalla distopica fantascienza africana del Double XX, le donne presentate nella serie *Pin-Up* sono una sorta di mutanti, delle sopravvissute alla violenza e alle tossine fisico/psichiche scaricate sopra e intorno ai loro corpi. Attaccando le pose seducenti delle modelle sugli skin magazine, i loro lineamenti selvaggi e calcati invitano timidamente lo spettatore a mettere su zampe, calli e piaghe insanguinate. Esseri curvilinei e menomati appena discesi dagli alberi, ti fissano con visi metà umani e metà animali. La spettrale cacciatrice-leopardo dalle lunghe gambe ha deciso che sarai il suo prossimo pasto non appena avrà digerito la giovane scimmia cacciata poco prima che ora porta di traverso sulle spalle. In che mondo

futuro, presente o passato queste bambole pin-up piene di capelli, che indossano l'abito migliore e macchiato della piantagione e le vesti della giungla, troveranno il proprio posto all'interno di spogliatoi, bagni, sale di rappresentanza, toilette, camerate e celle di prigione? E in quale genere ne sarà inserito l'adattamento cinematografico? Adulti? Horror? Fantascienza? Fantasy? Oppure, come suggerisce il braccio elegantemente sinuoso, in quale iconografia religiosa faranno da immagini votive?

Le forme femminili *Hybrid* potrebbero essere lette come commenti d'accompagnamento all'Africa subsahariana come luogo terreno in cui si realizzano le più vivide giustapposizioni del sublime e dell'orrifico; i prodotti chimici (o è solo gelato alla fragola sciolto?) gettati sui personaggi richiamano le sincopazioni africanizzate dei corpi costruiti a collage e dei *ghettoscape* di Romare Bearden, le stravaganti immaginazioni letterarie di Amos Tutuola e le 'hood societies' di Pedro Bell. Queste donne sembrano a volte concepite da un regno bizzarro fatto di notturne fantasticherie allucinogene e altre volte sembrano costruite dai rimasugli marcescenti delle fogne a cielo aperto, dei mucchi di spazzatura o di scarti tossici. Entrando alternativamente in una mutua sfigurazione giocosa o estatica, i loro gloriosi orifizi concedono fluidi vivifici e consacrano la terra con elisir tossici. Ma è ironico e significativo come la gran parte del "fuoriuscire" nell'arte di Wangechi non passi attraverso le consuete parti del corpo; spesso, il liquido sgorga piuttosto da punture e rotture fisiche. Si tratta, in altri termini, di un'estetica estatica del trauma. Senza dubbio c'è qui una strana fluttuazione, ma gran parte del movimento e dei volti di queste figure, che sono a volte seducenti e a volte sconcertanti, sublima le urla che provengono dalle maglie seviziate della storia.

La serie conclusiva *Body As Space* si struttura intorno a due priorità. Nella prima parte, l'artista rivendica i suoi quindici minuti di celebrità per la deturpazione artigianale della star afro-porno. Qui il corpo è inteso come centro del piacere, composto elusivamente attraverso un collage di tessuti tradizionali africani, una tregua momentanea nelle molteplici estasi agonizzanti che finora hanno forgiato il lavoro. La seconda parte, più ritualistica, cattolica e riflessiva, introduce un universo in cui angeli supercalifragilistici se la spassano su campi di sterminio, costeggiando le mura butterate di proiettili per presidiare un vaglio cattolico di sudici vestiti recuperati e di scheletri catalogati. In parte sacrificale e in parte oggetto di genocidio, qui il corpo trova una rispazializzazione rituale: ridotto ad una singola dimensione, esteso a proporzioni atmosferiche, brutalmente tagliato, fatto a pezzetti, trivellato di fori e liquefatto in pozze di sangue attende un contatto diretto con noi e il nostro godimento. Infine, sulla scia del massacro, degenera nuovamente nelle forme organiche del mondo naturale. E sembra giusto che la collezione termini con un altro orifizio a parete intera, che promette allo spettatore ancor più di questi teneri piaceri.

Non si tratta di un racconto stereotipico della comunità africana. C'è comunità, questo è chiaro, ma è una comunità prevalentemente costituita da spiriti e da forze naturali e dagli umanoidi (solitamente) solitari attraverso cui essi si manifestano per dispensare le proprie iraconde energie rigeneranti ad un mondo distorto. In sé, l'interpretazione dell'essere donna di Wangechi approda in definitiva ad una visione spirituale e alchemica, testimoniata dall'ossessione per la trasformazione presente in gran parte del suo corpus, costringendoci a leggere la bellezza dentro la deturpazione e la frammentazione come pura transizione verso una diversa tipologia di bellezza, o come una tipologia di bellezza in sé e di sé. È anche profondamente ecologica, perché le sue donne sono sempre in intimo accordo con i processi della natura. Queste eroine germogliano e si abbassano per sedurre, atterrire, incantare o spaventare a morte lo spettatore, pretendendo nuovi sistemi ideologici fatti di amore per l'ambiente, di amore erotico e di amore romantico per interpretare le propria esistenza e per rivendicare giustizia e nuova rettitudine.

Michael E. Veal, autore di *Fela: The Life and Times of an African Musical Icon* (2000) e *Dub: Soundscapes and Shattered Songs in Jamaican Reggae* (2007).

THE SPLENDOR OF OUR WORLD
SITTING DOWN WITH WANGECHI MUTU

Isolde Brielmaier with Wangechi Mutu

Sometimes all it takes is a simple mark, and from there a vision unfolds. For artist Wangechi Mutu the vision began with a single line that she would soon connect with other lines. Gradually, random thoughts were formed into small, poetic drawings of various shapes and forms in her sketchbook.

Mutu's marks have evolved organically, morphing with collage and painting to give birth to the myriad female figures that populate the fantastical realms in which she situates her characters. Mutu has continued to transform and manipulate these body forms over time. One senses a quest on her part. Each figure she creates is expressive and active in its performance, embarked on a search for identity, for voice, for answers. It is clear that Mutu is also seeking—ideas, missing pieces, something that is whole. As she has grown artistically she's expanded her quest, shifting the canvas from paper, to walls, and most recently, to the envelopment of entire spaces.

Mutu continues to extend her focus on the body—both as the core content of her work, and in relation to the viewer. Specifically, she probes the capabilities of the human figure as an exploratory site within large-scale installations. She constructs experiential environments in which to position her figures, and perhaps above all, to actively confront and engage the viewer. Mutu's installations are irrefutably linked to the appropriation of space and very much contingent upon the physical presence of bodies. Her female figures permeate the spaces in which she works, climbing onto walls, clinging to ceilings, wrapping around windows and columns. The works overtly demand that visitors negotiate the specific sites as a way of experiencing, and in turn generating meaning from Mutu's art. This encounter makes viewers intensely aware of their own bodies. Here, as with Merleau-Ponty's phenomenology, the visitor's consciousness, his or her body, and all sensory functions, form a complex entity that is intertwined, engaged and capable of perceiving.[1] In the context of Mutu's worlds, the body comprises the central content. The body is an active and capable subject that intentionally and consistently reconstructs experiences through a sense of space and an understanding of physical composition. The work is charged not only conceptually, but also experientially. Her figures are imbued with a sense of power and by extension her work underscores the agency of her audience in its engagement with, and consumption of, her art. These are the realms of possibilities that Mutu envisions and creates, forever drawing on the disturbing states and awe-inspiring splendor of the world in which we find ourselves.

1 For additional information regarding ideas of the body and phenomenology, see: Maurice Merleau-Ponty. *Phenomenology of perception / by M. Merleau-Ponty; translated from the French by Colin Smith*. London: Routledge & Kegan Paul; New Jersey: Humanities Press, 1981, ©1962.

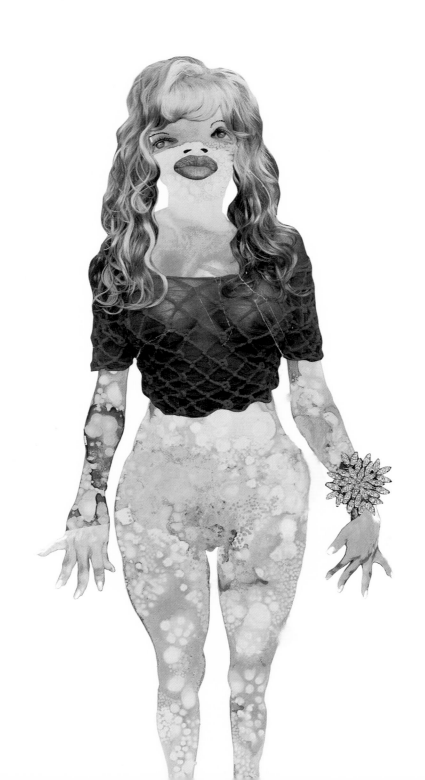

LA MERAVIGLIA DEL MONDO
UNA CHIACCHIERATA CON WANGECHI MUTU

Isolde Brielmaier con Wangechi Mutu

A volte serve semplicemente un segno e da lì si dispiega una visione. Per Wangechi Mutu, la visione ha avuto inizio con una linea singola che l'artista avrebbe presto collegato ad altre. Nel suo taccuino, i pensieri casuali hanno gradualmente acquisito la forma di figure e piccoli disegni poetici di varie fogge.

I segni di Mutu si sono evoluti organicamente, fondendosi con il collage e la pittura per dar vita alla miriade di figure femminili che popolano i regni fantastici in cui colloca i suoi personaggi. Nel corso del tempo, Mutu ha continuato a trasformare e a manipolare queste forme corporee. In lei si avverte il senso dell'indagine. Ogni figura che plasma ha una natura espressiva e attiva proiettata in una ricerca di identità, di voce e di risposte. È evidente che anche Mutu è alla ricerca, di idee, di pezzi mancanti, di unità integre. Alla sua progressiva crescita artistica ha fatto da contraltare un ampliamento della ricerca, che ha visto lo spostamento delle tele dalla carta alle pareti, fino ad arrivare, più recentemente, all'inclusione di interi spazi.

Mutu non cessa di estendere il suo focus sul corpo, sia come tema centrale del proprio lavoro, sia in relazione allo spettatore. Indaga in particolare le potenzialità della figura umana come territorio di analisi all'interno di vaste installazioni. Costruisce spazi esperienziali nei quali posizionare le proprie figure e soprattutto incontrare e coinvolgere lo spettatore. Le installazioni di Mutu sono inconfutabilmente connesse all'appropriazione dello spazio e fortemente subordinate alla presenza fisica dei corpi. Le sue figure femminili permeano i suoi spazi di lavoro arrampicandosi sulle pareti, aggrappandosi ai soffitti, avvolgendosi intorno a finestre e colonne. Le sue opere rivendicano esplicitamente un confronto dei visitatori con i luoghi specifici come strumento di conoscenza, che genera senso a partire dall'arte di Mutu. L'incontro rende gli spettatori profondamente consapevoli dei loro stessi corpi. Qui, come nella fenomenologia di Merleau-Ponty, la coscienza del visitatore, il di lui o di lei corpo, e tutte le sue funzioni sensoriali vanno a costituire un'entità complessa che è "tessuta insieme", impegnata e capace di percezione.[1] Nel contesto dei lavori di Mutu, il corpo costituisce il contenuto centrale. È un soggetto attivo ed efficiente che ricostruisce intenzionalmente e coerentemente le esperienze attraverso un senso dello spazio e una cognizione della composizione fisica. L'opera è carica da un punto di vista non solo concettuale, ma anche esperienziale. Le figure sono intrise di un senso di potenza e, per estensione, l'opera sottolinea la partecipazione attiva del pubblico nel coinvolgimento e nella fruizione della sua arte. Questi sono i regni del possibile che Mutu immagina e crea, sempre attingendo a stati emotivi inquietanti e alla magnificenza dell'universo in cui viviamo.

1 Per maggiori informazioni in merito alle idee sul corpo e sulla fenomenologia, si veda: Maurice Merleau-Ponty, *Phénoménologie de la perception*, Paris, Gallimard, 1945; tr. it. A. Bonomi, *Fenomenologia della percezione*, Il Saggiatore, Milano, 1965 | *by M. Merleau-Ponty: translated from the French by Colin Smith*. London: Routledge & Kegan Paul; New Jersey: Humanities Press, 1981, ©1962.

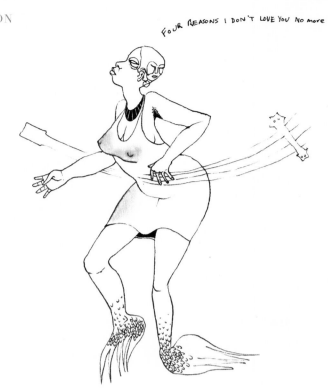

My body is a map.
I sense its citational terrain.
That genealogy of memories, histories and utterances
follows me like a thousand foot braid.
With each strand added to this thick black plait, the
telling shifts and unravels.

Dripping, reaching and breathing, this embodied past
bears designs of its own posture.
Mind that the gestures are never the same.
Glances lit by five hundred eyes, the legacy of
history's gaze watches over me.

Broken pacts, tender words, crowded boats and bare
winter feet.
The inscriptions of these moments dance across my
limbs as I try to stand still.
Yet there is no fixing of this body's motion.
And I laugh at the vanity of my attempt.

Even in slumber my body performs a web of legacies.
So I sit, and ask, and watch, and listen,
Searching for the map's origins, I am eased into
knowing they will never be found.

—JYOTI ARGADE

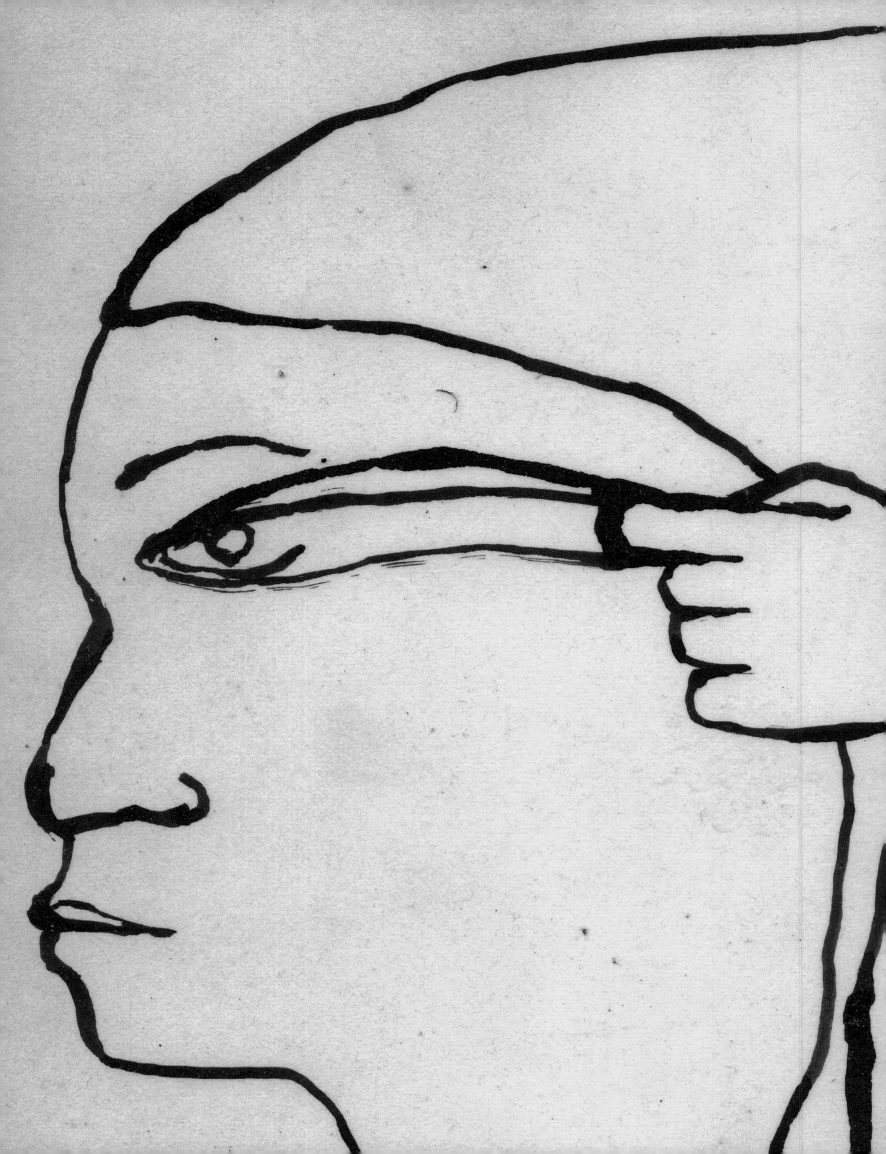

CHAPTER ONE
LINE DRAWINGS

INTERVIEW

PART I: THE BODY

Isolde Brielmeier with Wangechi Mutu

ISOLDE: *You explore and challenge the ways in which the female body is used as a site of political and cultural ambivalence—a subject upon which the world works out its issues, tensions and questions. I am interested in this appropriation, this "using" of the body. You use the body as a site upon which to articulate your vision and ideas. Can you elaborate on this phenomenon of borrowing, the re-configuring of "woman"?*

WANGECHI: I'm quite aware that one of the inherent contradictions in "using" the female body both as a site for debate and thought, as well as a motif that attracts and dilates the mind's eye, is that this female body yet again is being utilized and mounted as a means to an end. However, being a woman (which sounds redundant, but is not obvious to everyone), I exist in an awareness and consciousness that is essentially the problematic of this body. I don't have the privilege of fetishizing some form of invisibility. So, having said that, I think that the body is a very "natural" point of departure for me. It's the simplest way to ask or demand that the viewer immediately place themselves somewhere relative to the issues, imagery and ideas they're about to encounter. I guess I might also add that men tend to idealize or demonize women's bodies. I think it's a very normal thing when your experience of the female is primarily from an external perspective, like a son with his mothers' breast, a lover his woman's skin, and smell and so forth. But as a woman, that deep and wonderful churning connection and disconnection with your body is very real and often extreme. It is for this reason that I turn the body inside out, extending and reconfiguring it.

INTERVISTA

PARTE I: IL CORPO

Isolde Brielmeier con Wangechi Mutu

ISOLDE: *Esamini e metti in discussione le modalità secondo cui il corpo femminile viene usato come luogo di conflitto politico e culturale; come soggetto nel quale il mondo risolve le proprie dispute, le proprie tensioni e i propri interrogativi. È proprio questa appropriazione che mi interessa, questo "utilizzo" del corpo. Usi il corpo come luogo dove articolare la tua visione e le tue idee. Potresti approfondire questo fenomeno di prestito e di riconfigurazione del soggetto "donna"?*

WANGECHI: Sono assolutamente consapevole che una delle contraddizioni intrinseche dell'"usare" il corpo femminile, sia in qualità di luogo di discussione e di riflessione sia come motivo che attrae e amplifica l'immaginazione, è quella per cui, ancora una volta, questo corpo femminile viene utilizzato e messo in mostra come strumento finalizzato ad uno scopo. Tuttavia, essendo una donna (suona superfluo, ma in effetti non è così evidente a tutti), vivo in una consapevolezza e in una coscienza che costituiscono essenzialmente la problematicità di questo corpo. Non possiedo il privilegio di feticizzare una qualche forma di invisibilità. Detto questo, credo che per me il corpo sia un punto di partenza molto "naturale". È il modo più semplice per chiedere o imporre agli spettatori di collocarsi in uno spazio in qualche modo correlato alle problematiche, alle immagini e alle idee in cui stanno per imbattersi. Suppongo di poter aggiungere che gli uomini tendono ad idealizzare o a demonizzare i corpi femminili. Credo che l'esperienza del femminile che avviene principalmente da una prospettiva esterna, come nel caso di un figlio con il seno della madre, o di un amante con la pelle e l'odore della propria donna, sia qualcosa di estremamente normale. Ma come donna, quel legame e quella frattura con il tuo corpo così profondi, straordinari e sconvolgenti sono assolutamente autentici e spesso estremi. È questo il motivo per cui rovescio completamente il corpo, estendendolo e riconfigurandolo.

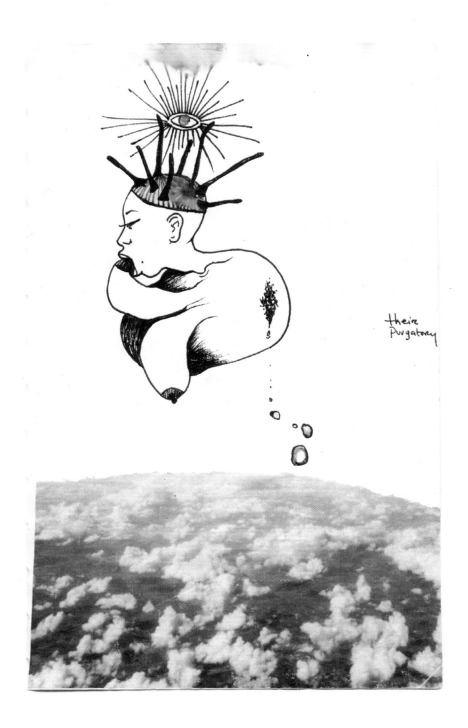

their
Purgatory

Sketchbook Drawing, 1996, Ink drawing on watercolor paper, Actual Size

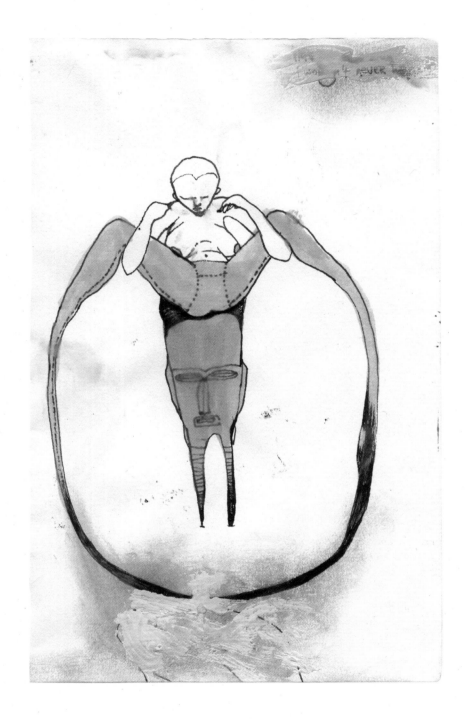

Sketchbook Drawing, 1996, Ink pen collage on paper, Actual Size

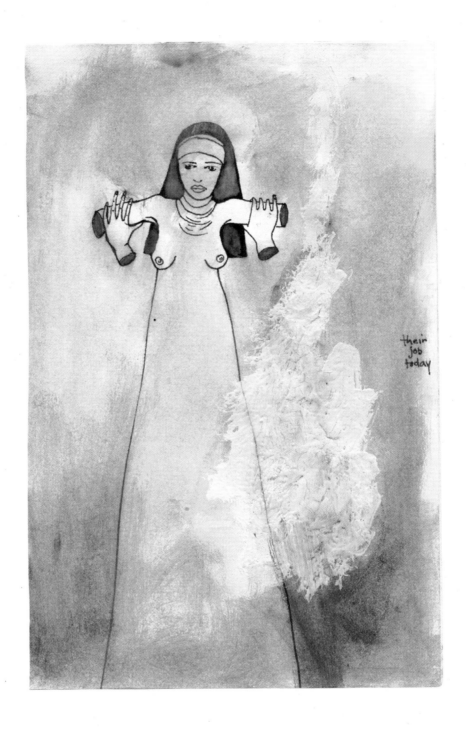

Sketchbook Drawing, 1996, Ink pen on paper, Actual Size

A Shady Promise

Sketchbook Drawing, 1998, Ink pen on paper, Actual Size

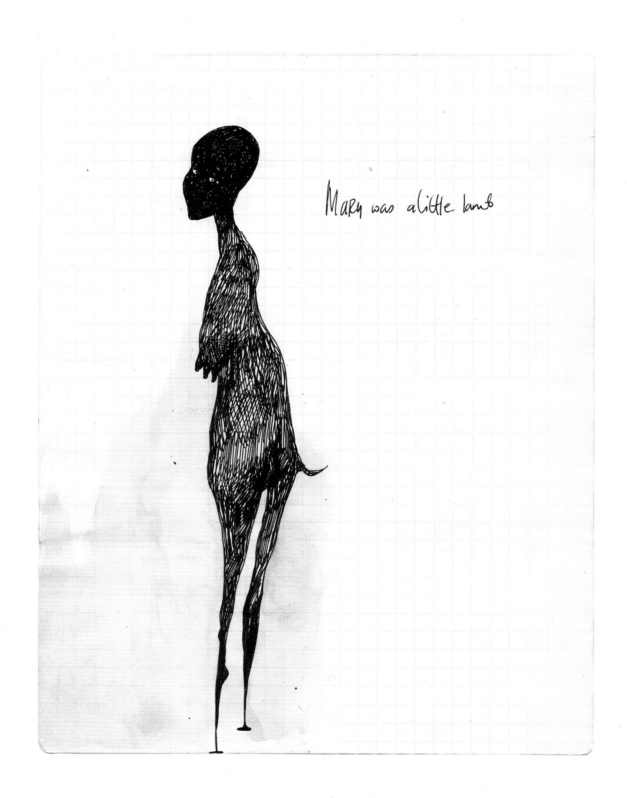

Mary was a little lamb

Notebook Drawing, 1995, Ink pen on paper, Actual Size

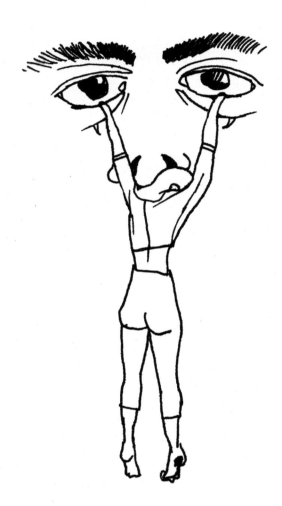

Sketchbook Drawing, 1998, Ink pen on paper, Actual Size

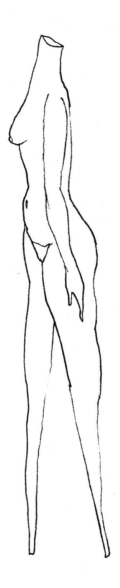

Sketchbook Drawing, 1998, Ink pen on paper, Actual Size

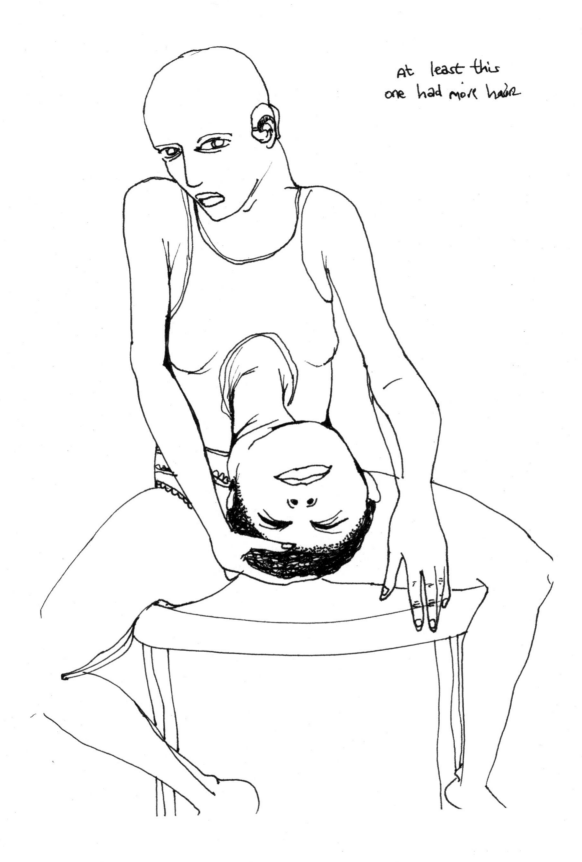

At least this
one had more hair

Sketchbook Drawing, 2001, Ink pen on paper, Actual Size

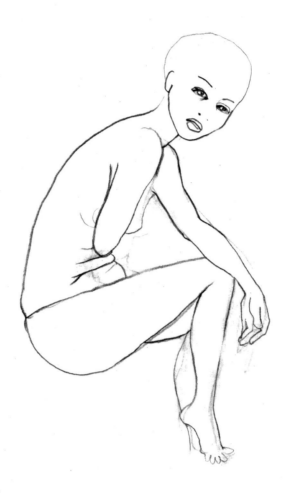

Sketchbook Drawing, 2001, Ink pen on paper, Actual Size

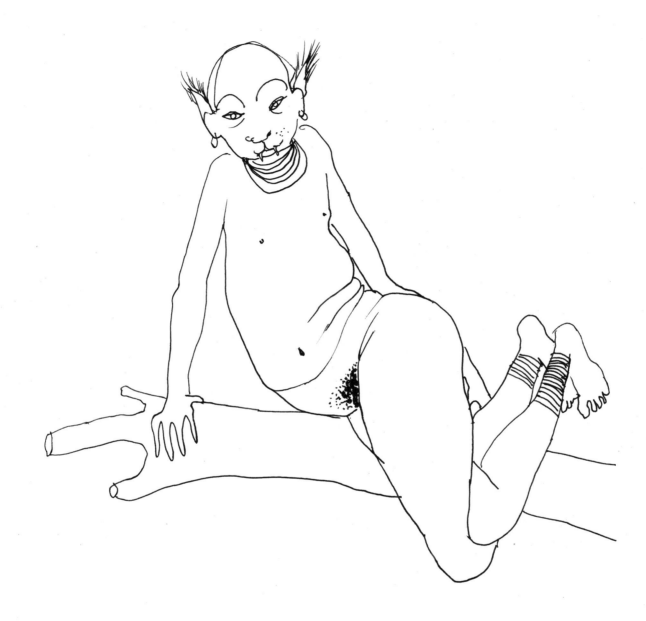

I've been trying so hard to be feline

Sketchbook Drawing, 2001, Pencil, Actual Size

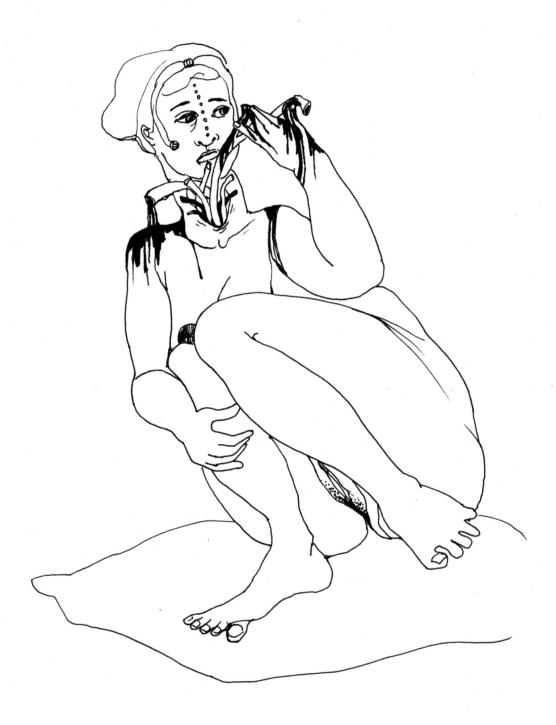

Sketchbook Drawing, 2001, Ink pen, Actual Size

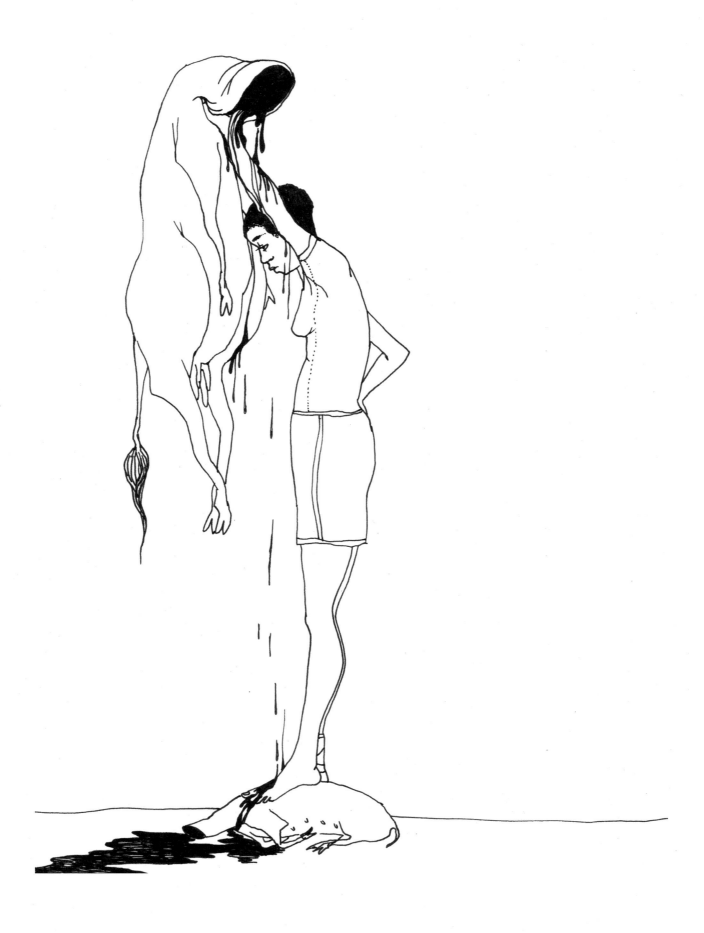

Sketchbook Drawing. 2001, Ink pen, Actual Size

A Shady Promise

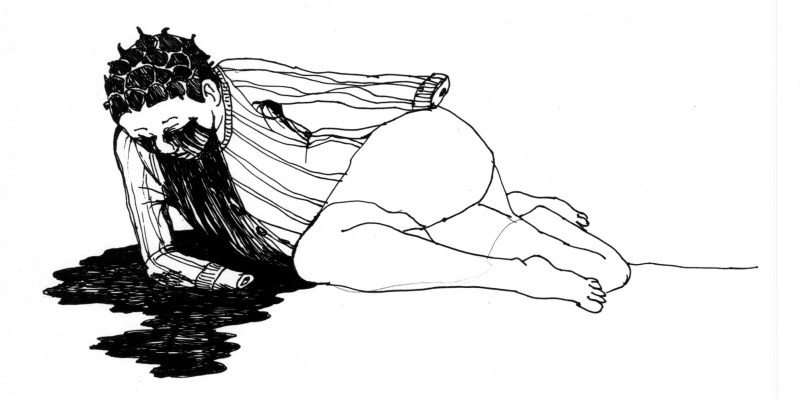

Sketchbook Drawing, 2000, Ink pen, 7¾" x 10¾"

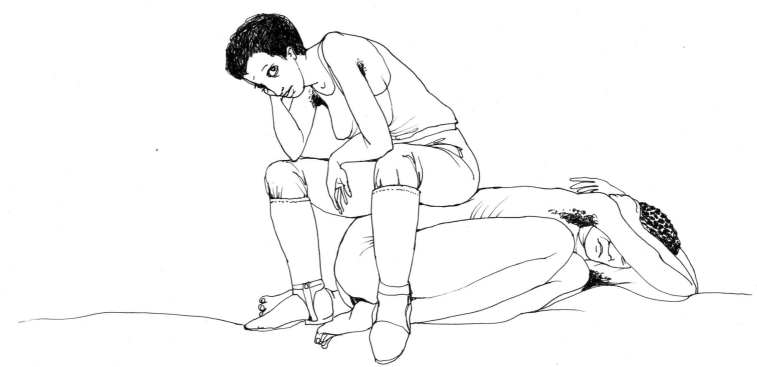

"No but it was my first time..." she thought to herself

Sketchbook Drawing, 2001, Ink pen, 7¾" x 10¾"

A Shady Promise

Sketchbook Drawing, 2000, Ink pen, 7¾" x 10¾"

Sketchbook Drawing, 2001, Ink pen, 7¾" x 10¾"

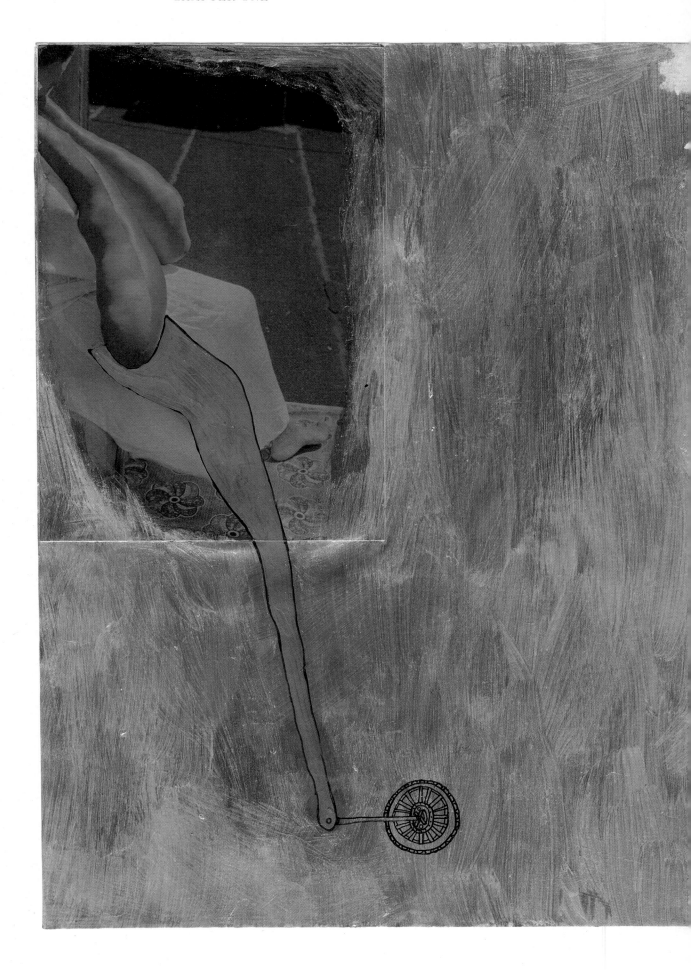

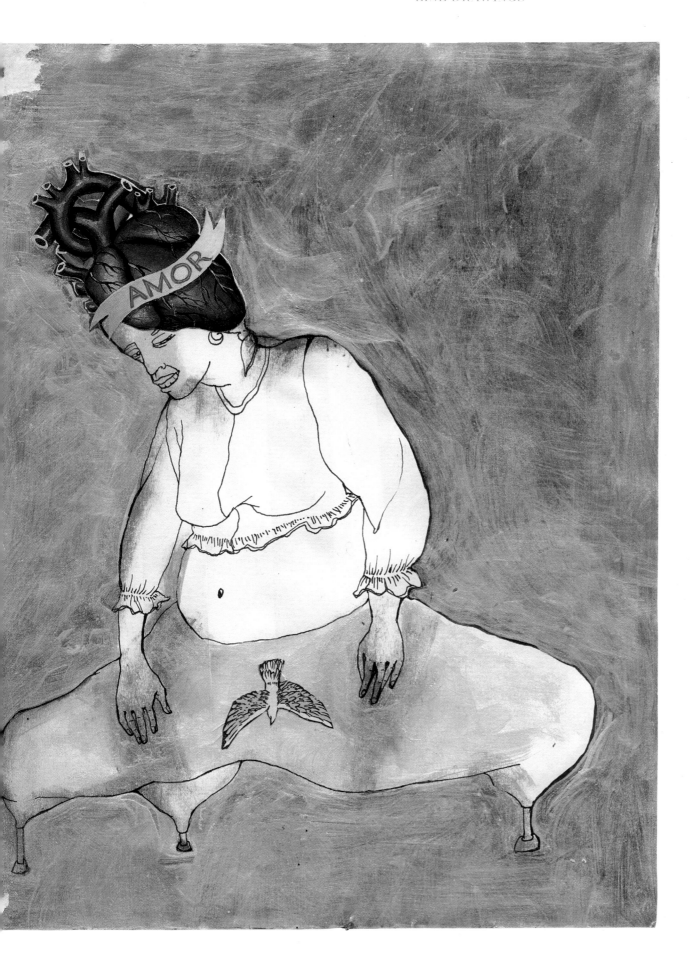

Sketchbook Drawing, 1999, Ink pen, 15½" x 10⅝"

A Shady Promise

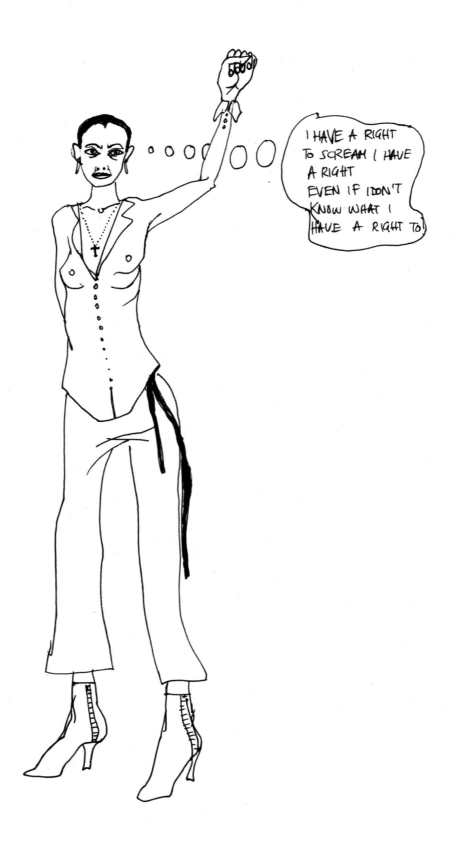

Sketchbook Drawing, 2001, Ink pen, Actual Size

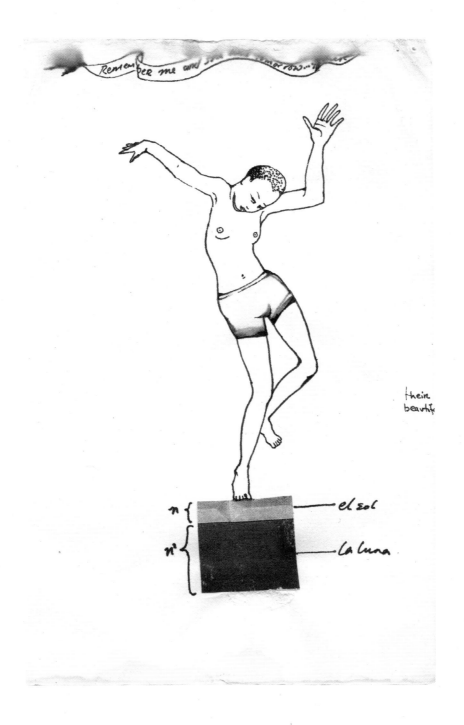

Sketchbook Drawing, 1996, Photo collage, ink and paint, Actual Size

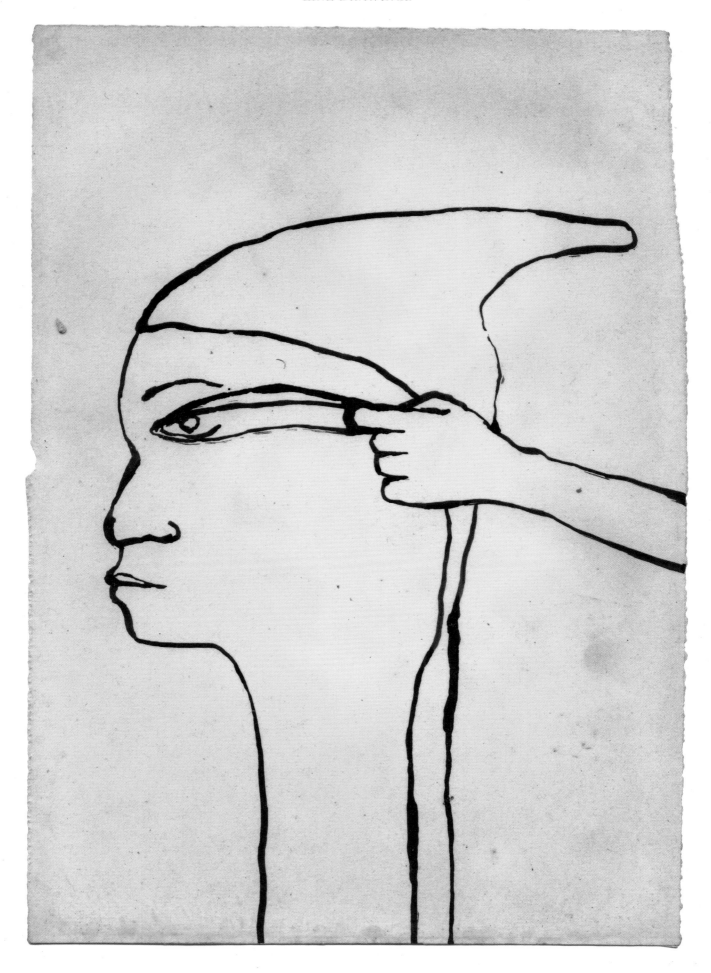

Sketchbook Drawing, 1998, Ink pen and collage, Actual Size

A Shady Promise

Why do you not draw men ?

Sketchbook Drawing, 2001, Ink pen, Actual Size

The all-American pin-up arches her back, her tits and ass protruding. She sucks in and stretches out against the cold chrome of bombers and aircraft, on plastic playing cards and cheap wall calendars. She lives in sweaty lockers and adorns army barracks, beside plastic rosary beads and pictures of the Virgin Mary rocking sweet baby Jesus in her arms. Her name is Marilyn, Lolita, Dita. She is someone's high-school sweetheart, a Playboy centerfold with the face of your kid sister, an obsession, a fantasy… and she fits in your pocket, stained and crusted.

She is untouchable, from too much touching. The stiletto straps strangle her limbs and cut into her flesh. They explode wide-open her infected wounds, oozing puss marbleized blood the color of her pretty, painted toenails. She crouches, arches, and crawls. Her sutured, supermodel pout bends to become a serpentine smile. She narrows her eyes and gazes outward… inwardly. It tells you that she is a survivor, a victim, a cyborg, a mother, a bitch, a reptile, a hunter, a nightmare, a mute… and a pin-up.

—CHRISTINE Y. KIM

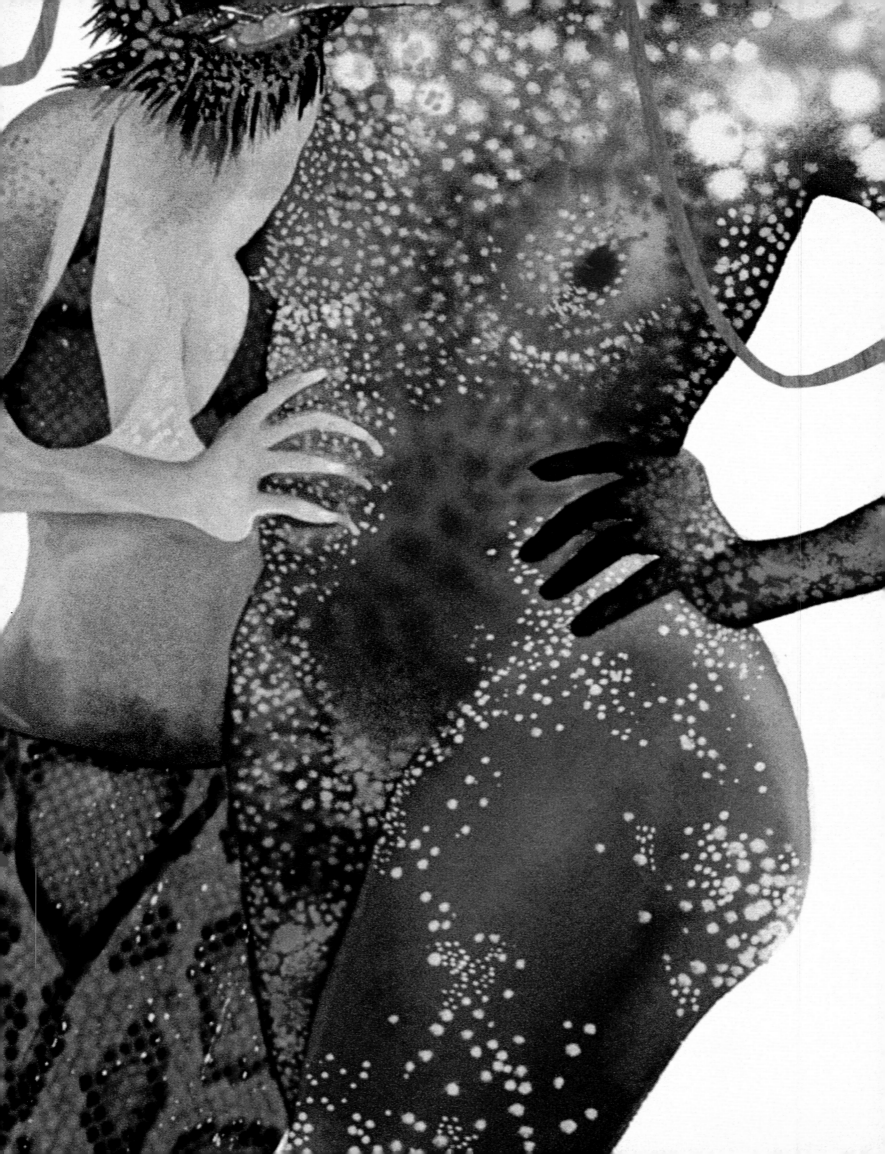

CHAPTER TWO

THE PIN-UP

INTERVIEW

PART II: WATERCOLOR FEMME NOIR

Isolde Brielmeier with Wangechi Mutu

ISOLDE: *It is clear that your most recent figures have entered into a new state of being. They are abstract, fractured, jumbled. But let's go back to your early pin-ups. As you've drawn from magazine images and ideas of female icons, it seems these figures are more recognizable in a sense. I see models, celebrities, Lil' Kim perhaps — more visible, public women whose appearance comes under constant scrutiny. There is a sense of overt construct and artificiality in your pin-ups, but you haven't executed a full reconfiguring of the body. Are you still challenging the ways in which women's bodies are central to culture, to the production of beauty, and to the maintenance of a gendered status quo?*

WANGECHI: I think one of the most powerful aspects about drawing is how honest and direct the medium is. When I began making watercolour pin-ups I was really not interested in exhibiting or showing them. My personal views as a feminist, as a woman, as a maker of images, seemed to clash with most of the characteristics of these messed up belles. At the same time, the process was therapeutic and self-indulgent, and even a little regressive. I remember I was very nomadic at the time and using the subway. I'm not suggesting that it was a direct lift, but I was obsessed with the defacement of posters and celebrities that seems like a cosmetic social contract between a primal, pseudo-destructive expression on public space, and a convoluted paper doll game. I managed to create an image that was saccharine, vindictive, self-deprecating, and damaged, yet pleasant to the eye. What I ended up with was a long chorus of female imagery that hacked away at magazine culture, white standards of beauty, and the obsession with body augmentation. Eventually watercolour became second nature, but the very organic, emotional temperament of the paper prevented me from loading on more liquid and heavier materials. Thus began my transition to larger collage, and with this shift in the fluidity and morphing of the figures came a move to super-synthetic Mylar.

INTERVISTA

PARTE II: FEMME NOIR AD ACQUERELLO

Isolde Brielmeier con Wangechi Mutu

ISOLDE: *Appare evidente come le tue figure più recenti siano entrate in un nuovo stato esistenziale. Sono astratte, frammentate, disordinate. Ma torniamo alle tue pin-up dell'inizio. Avendo attinto da immagini di riviste e da repertori di icone femminili, tali figure appaiono in qualche misura più riconoscibili. Vediamo modelle, celebrità, forse Lil'Kim: donne più in vista, donne popolari la cui apparenza è continuamente sottoposta a giudizio. Le tue pin-up rivelano un senso esplicito di costruzione, di artificialità, ma qui non hai apportato una totale riconfigurazione del corpo. Stai ancora criticando le modalità secondo cui il corpo delle donne è essenziale alla cultura, al processo di produzione della bellezza e al mantenimento di uno status quo genderizzato?*

WANGECHI: Credo che gli aspetti più potenti del disegno siano l'estrema onestà e la schiettezza dello strumento. Quando cominciai a fare le pin-up ad acquerello, non mi interessava minimamente esporle o farle vedere. Mi sembrava che le mie prospettive personali, di femminista, di donna e di creatrice di immagini stridessero con la maggior parte delle caratteristiche di queste bellezze scompigliate. Allo stesso tempo, il processo era terapeutico e accondiscendente verso me stessa. Ricordo come in quel periodo fossi assai in movimento e quanto usassi la metropolitana. Con questo non voglio dire che si sia trattato di un passaggio diretto, ma ero ossessionata dalla deturpazione di manifesti e di celebrità che sembrava quasi un contratto sociale cosmetico tra un'espressione primitiva e pseudo-distruttiva sullo spazio pubblico ed un gioco arzigogolato di bambole di carta.. Sono riuscita a creare un'immagine stucchevole, maligna, autocensurantesi e corrotta, ma anche piacevole alla vista. E alla fine mi sono trovata con un interminabile coro di ritratti femminili che facevano a pezzi la cultura delle riviste, gli standard bianchi della bellezza e l'ossessione per l'aumento di peso. L'uso dell'acquerello sarebbe poi diventato qualcosa di naturale, ma la natura organica ed emotiva della carta mi impediva di aggiungere dei materiali più liquidi e pesanti. Da qui ha avuto origine la transizione verso il collage più ampio e a questa svolta nella fluidità e nel *morphing* delle figure si è associato anche un passaggio verso il supersintetico Mylar.

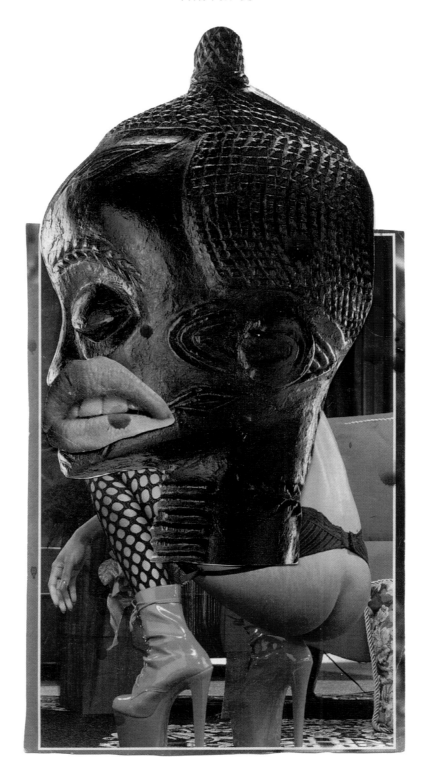

Pin-Up, 2005, Ink and magazine collage, 7 ¹/₂" x 4"

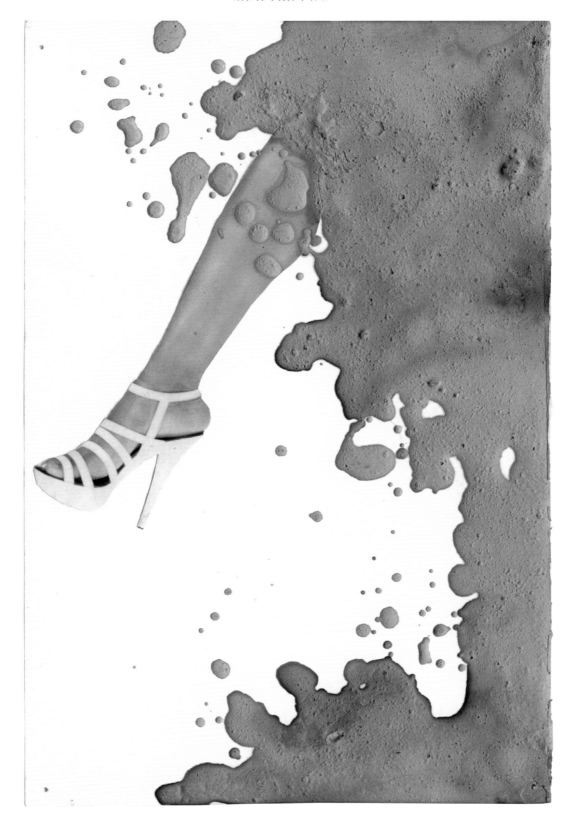

MUD, 2003, Ink and collage on paper, 8 $^1/_2$" x 5 $^1/_2$"

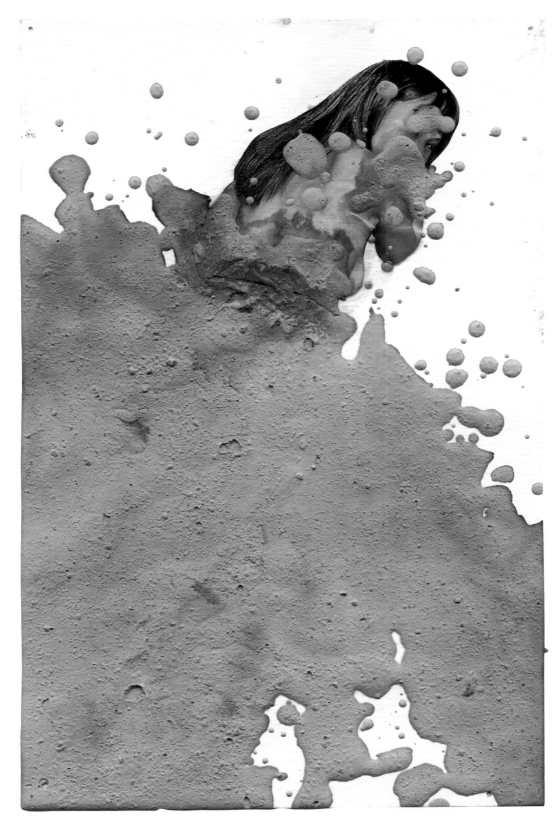

MUD, 2003, Ink and collage on paper, 8 ½" x 5 ½"

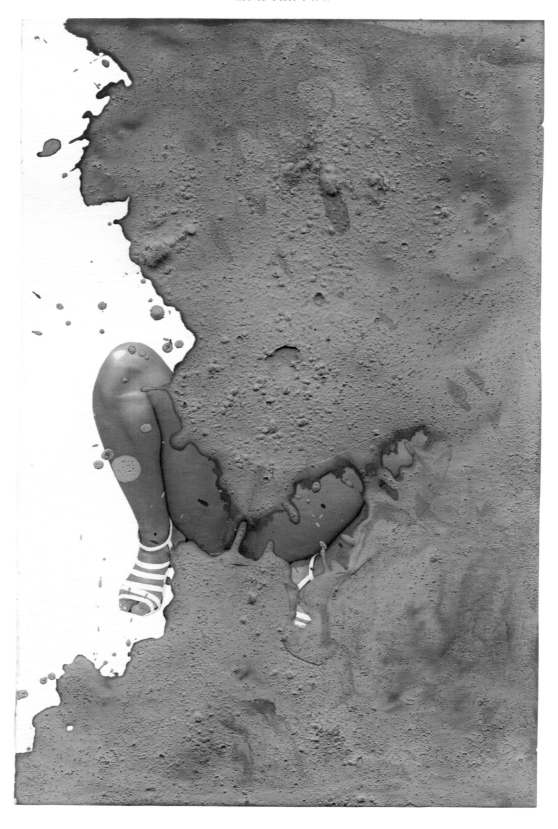

MUD, 2003, Ink and collage on paper, 8 ¹/₂" x 5 ¹/₂"

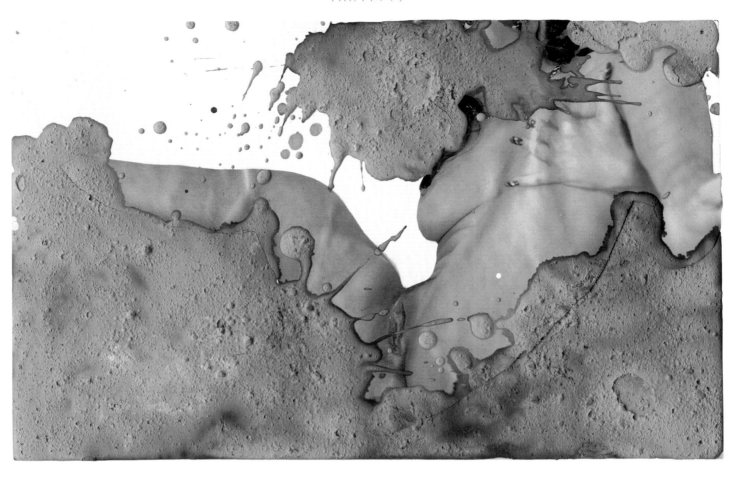

MUD, 2003. Ink and collage on paper, 5 ¹/₂" x 8 ¹/₂"

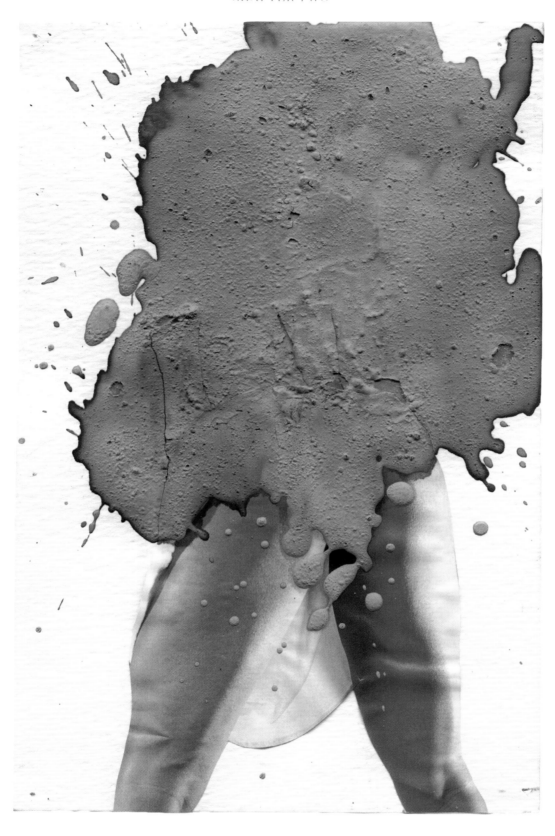

MUD, 2003, Ink and collage on paper, 8 ½" x 5 ½"

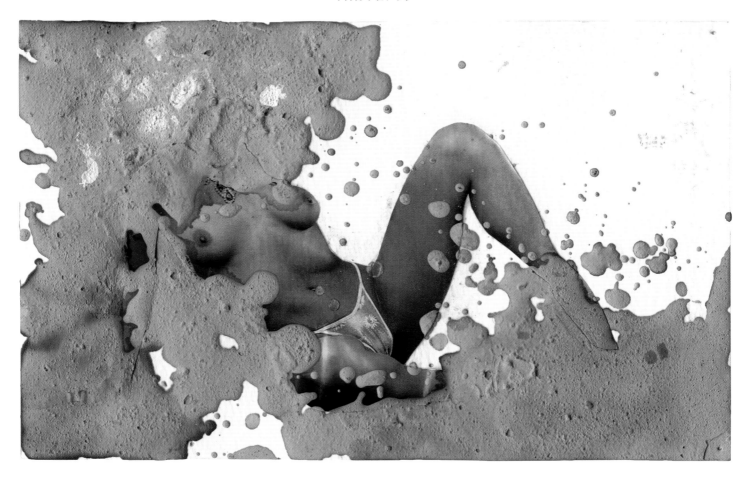

MUD, 2003, Ink and collage on paper, 5 ¹/₂" x 8 ¹/₂"

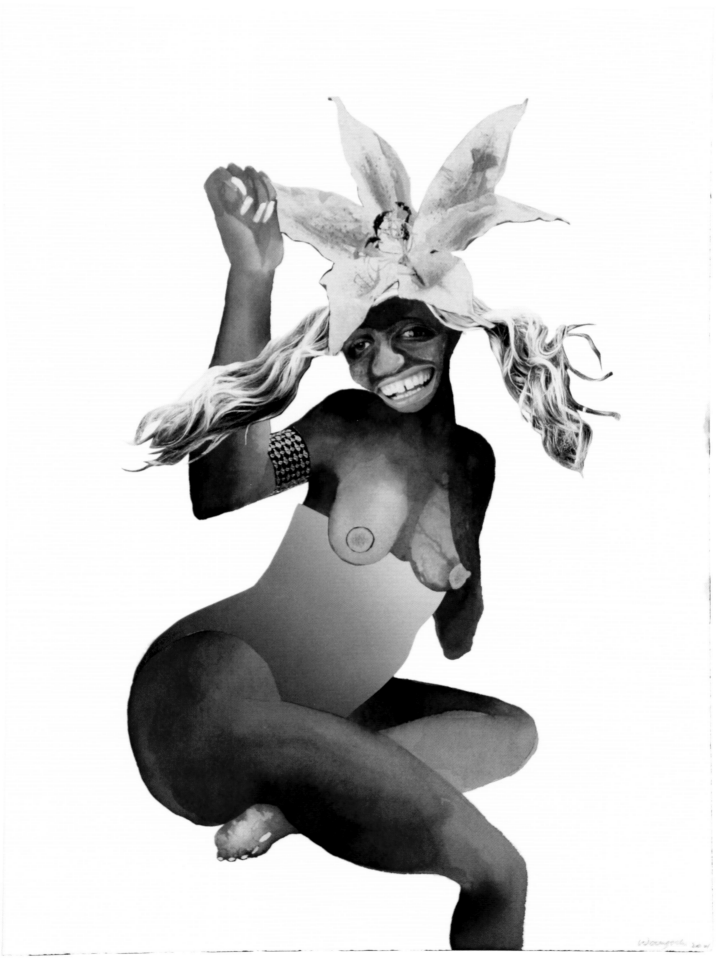

Pin-Up, 2001, Watercolor collage on paper, 13" x 10"

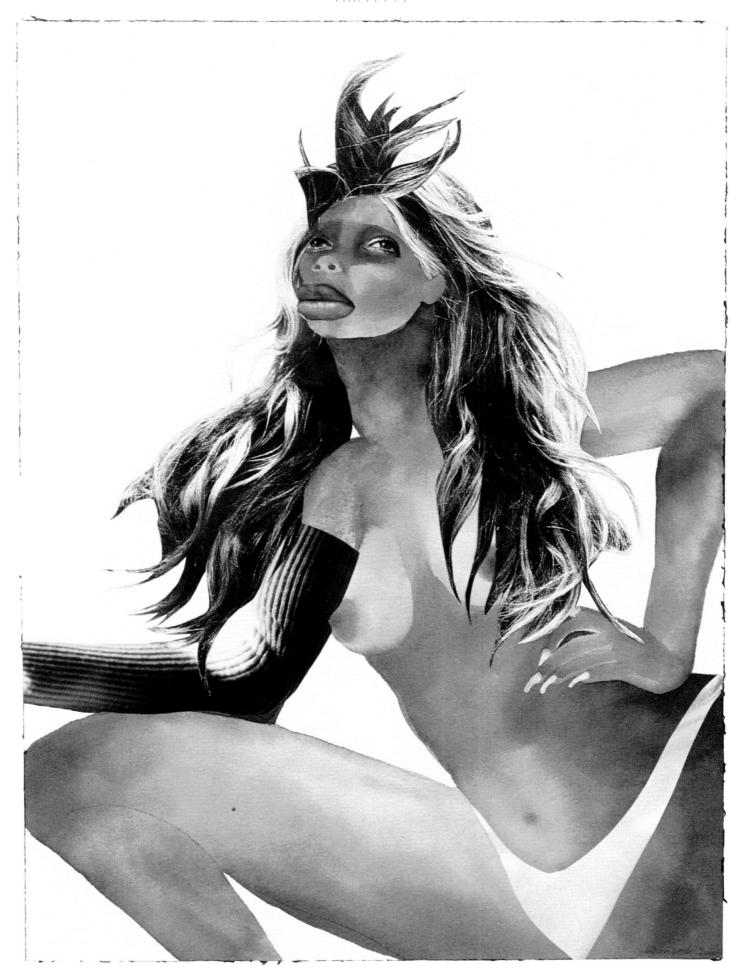

Pin-Up, 2001, Watercolor collage on paper, 13" x 10"

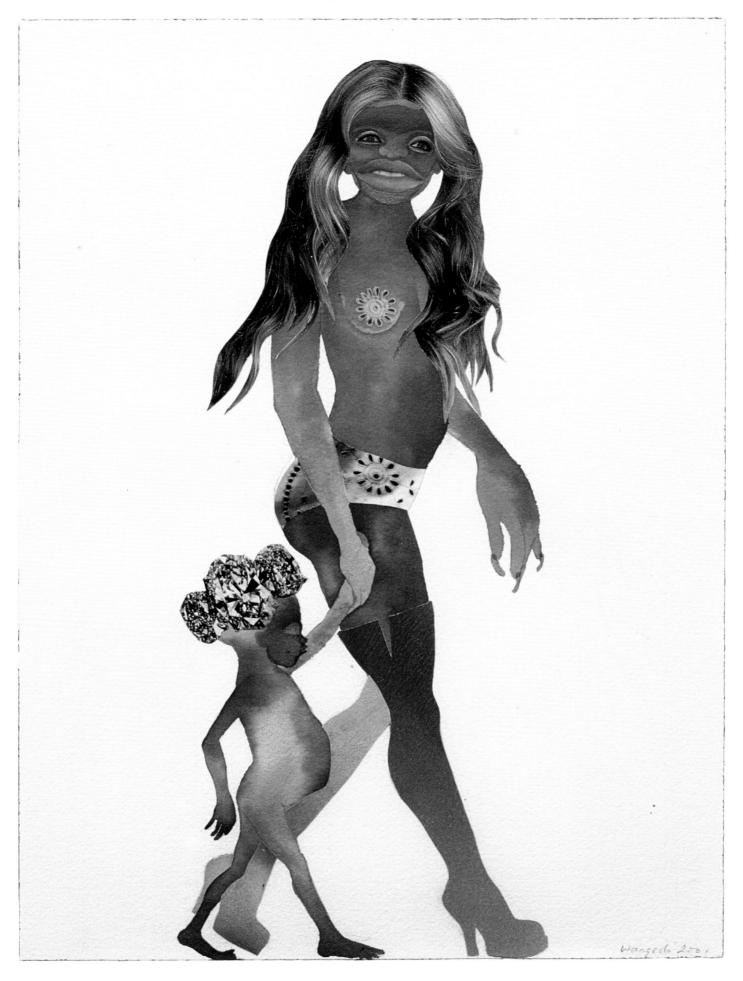

Pin-Up, 2001, Watercolor collage on paper, 13" x 10"

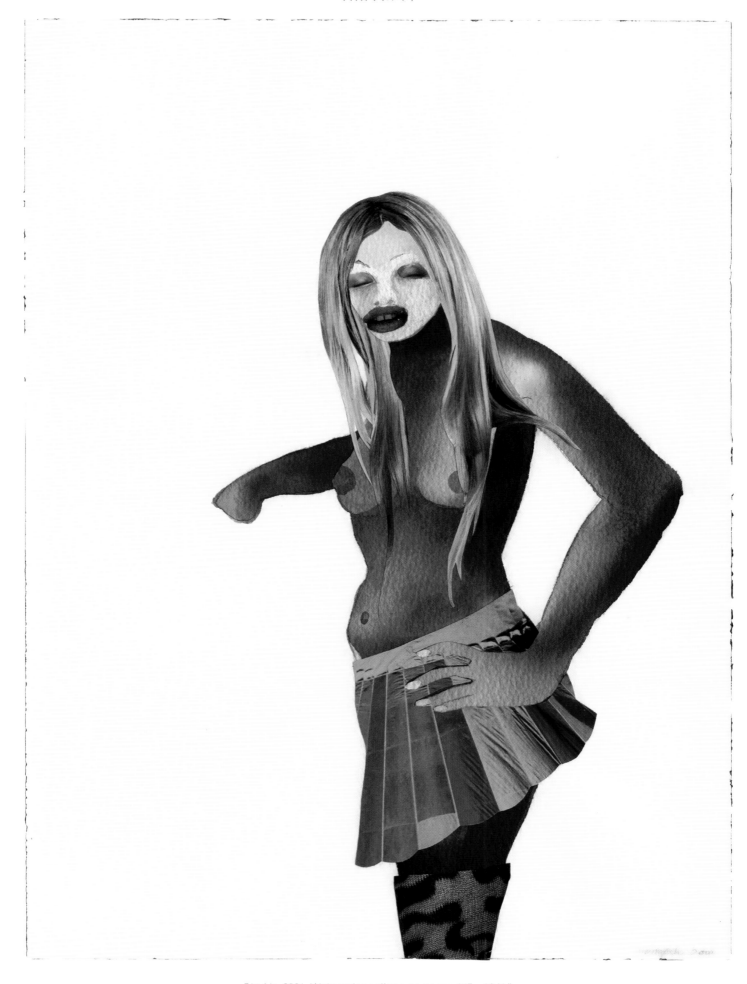

Pin-Up, 2001, Watercolor collage on paper, 14" x 10 ½"

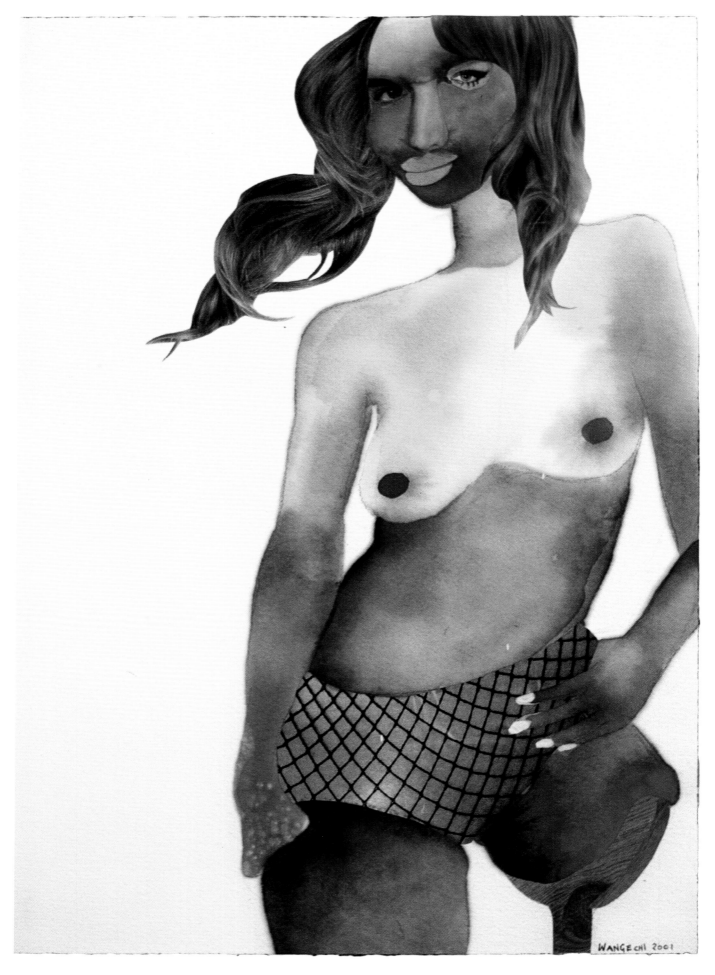

Pin-Up, 2001, Watercolor collage on paper, 13" x 10"

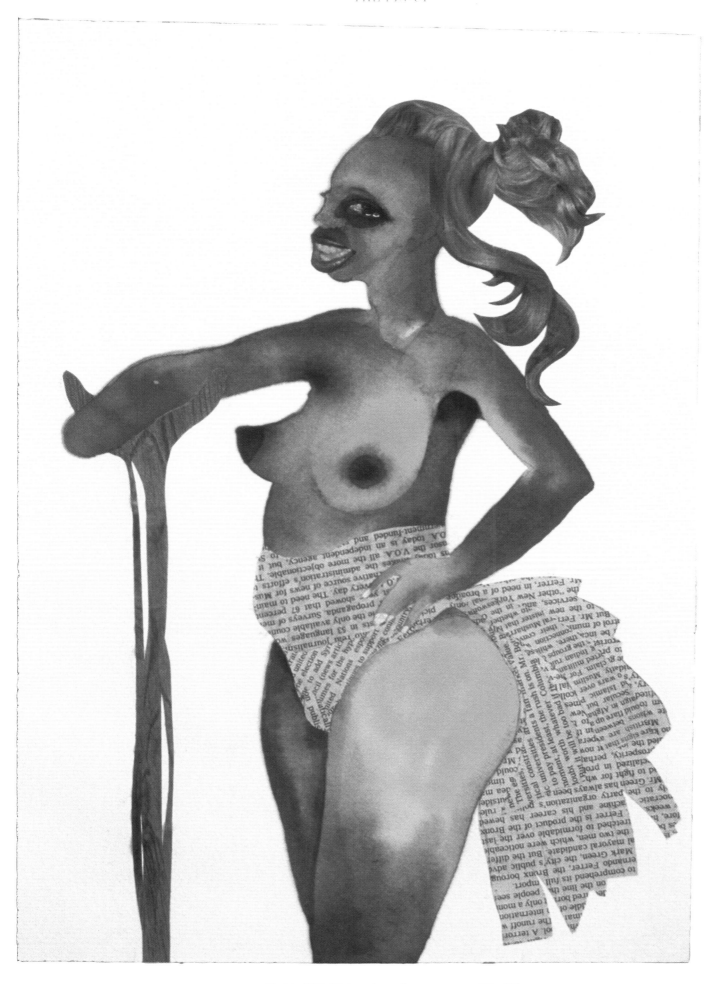

Pin-Up, 2001, Watercolor collage on paper, 13" x 10"

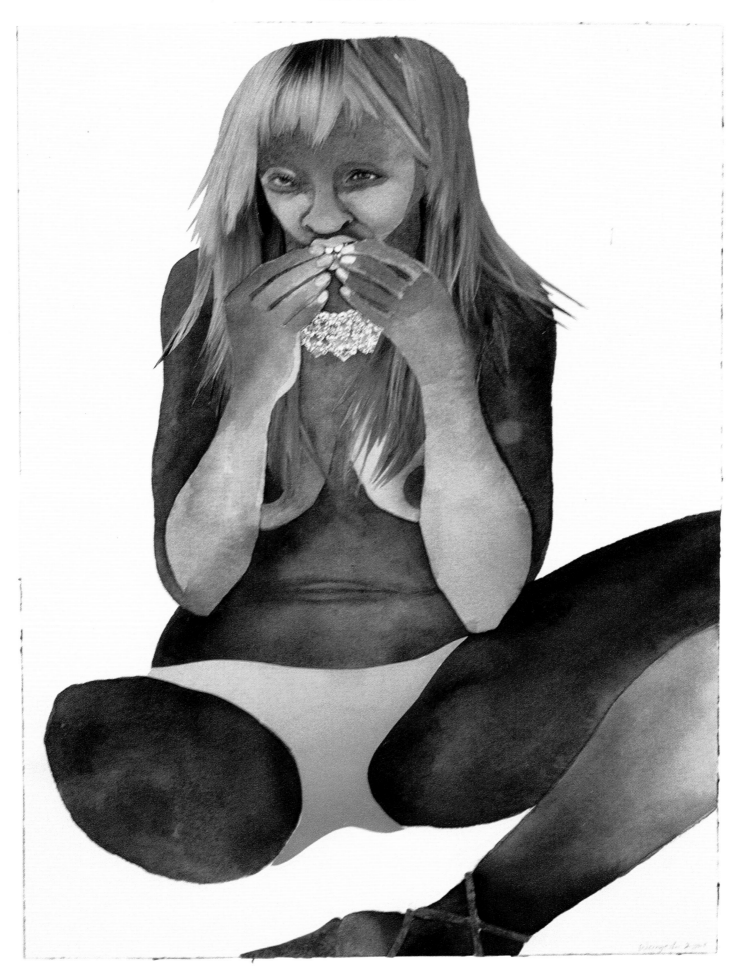

Pin-Up, 2001. Watercolor collage on paper, 13" x 10"

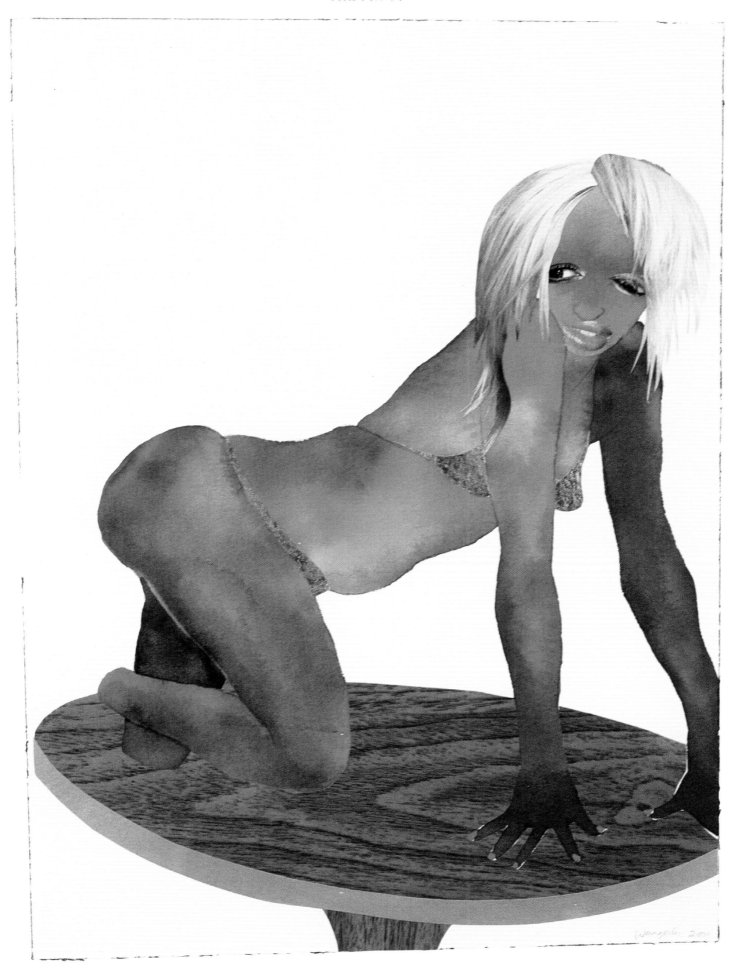

Pin-Up, 2001, Watercolor collage on paper, 13" x 10"

A Shady Promise

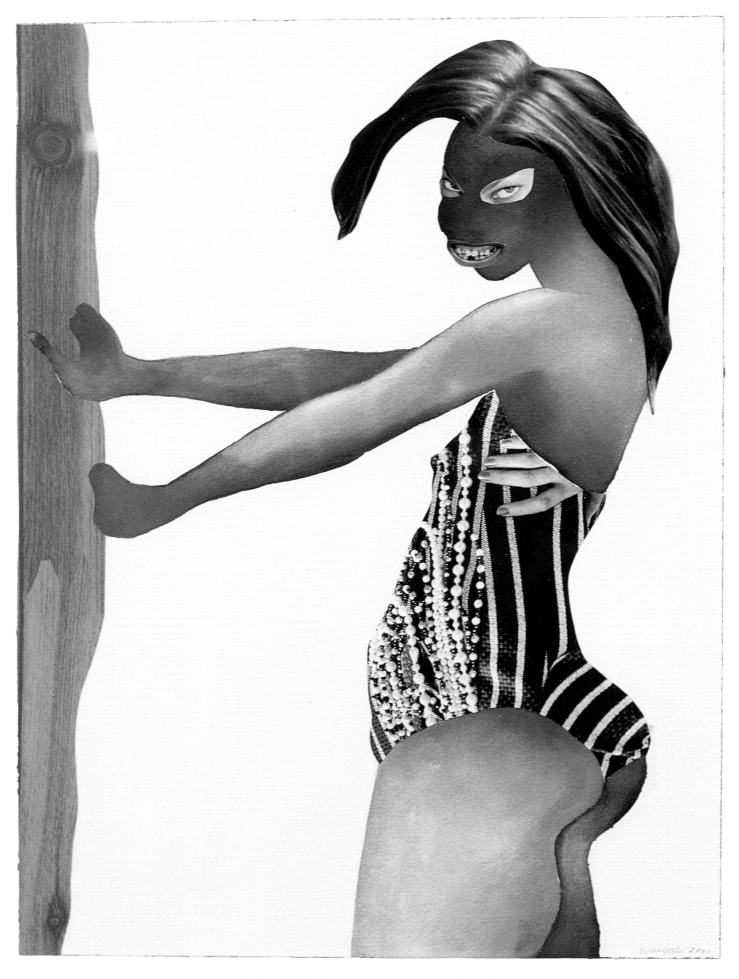

Pin-Up, 2001, Watercolor collage on paper, 13" x 10"

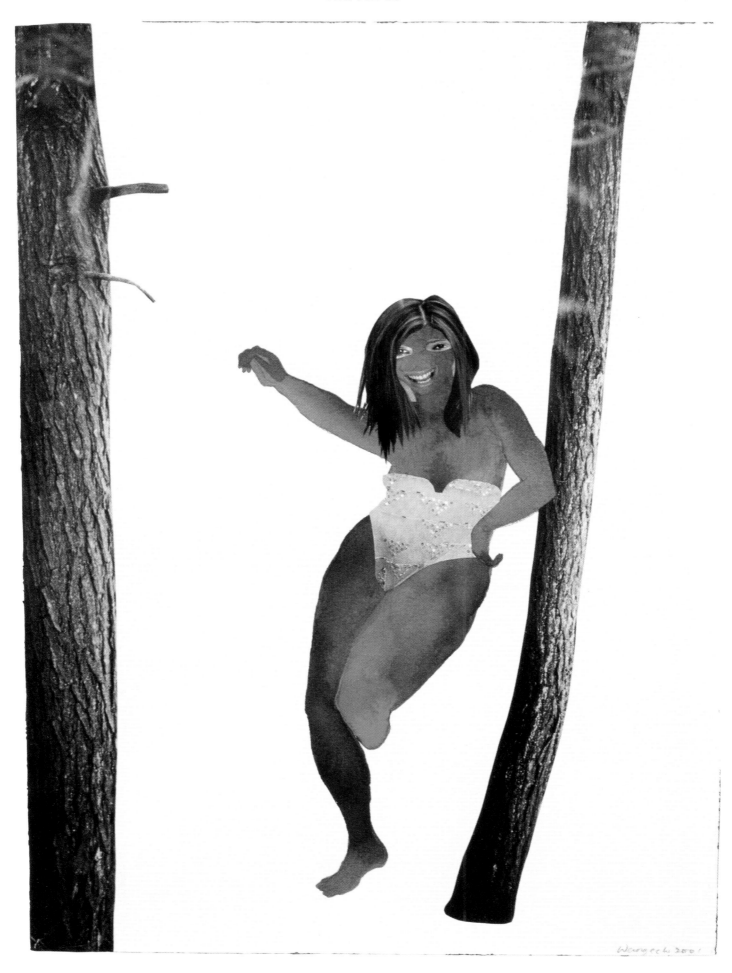

Pin-Up, 2001. Watercolor collage on paper. 13" x 10"

A Shady Promise

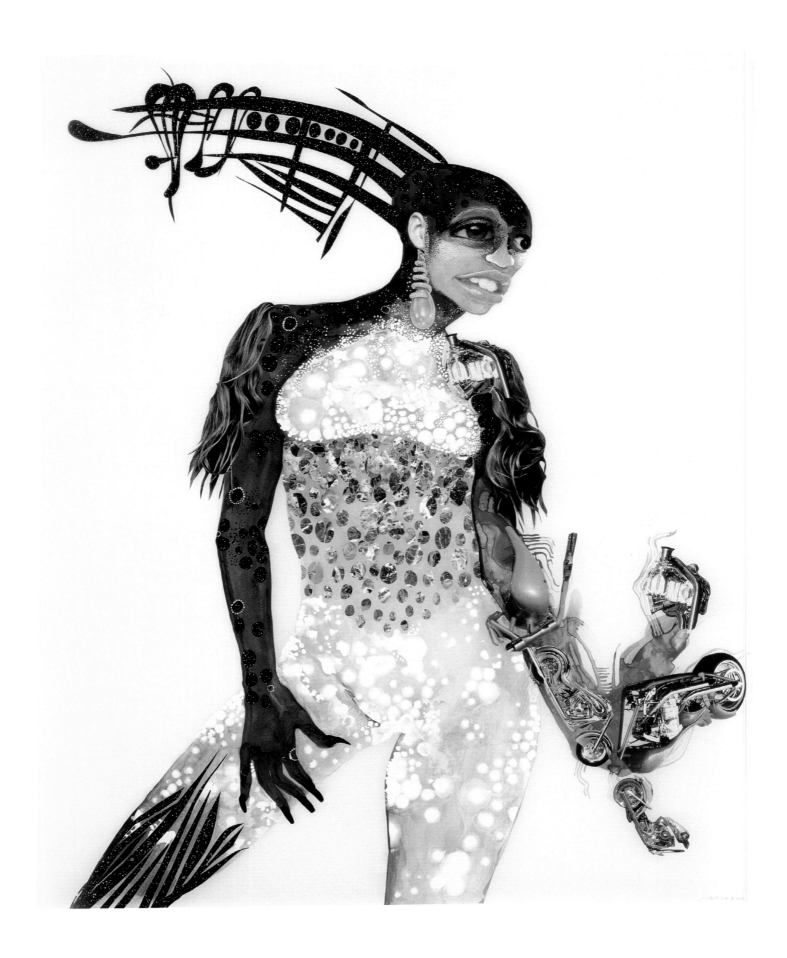

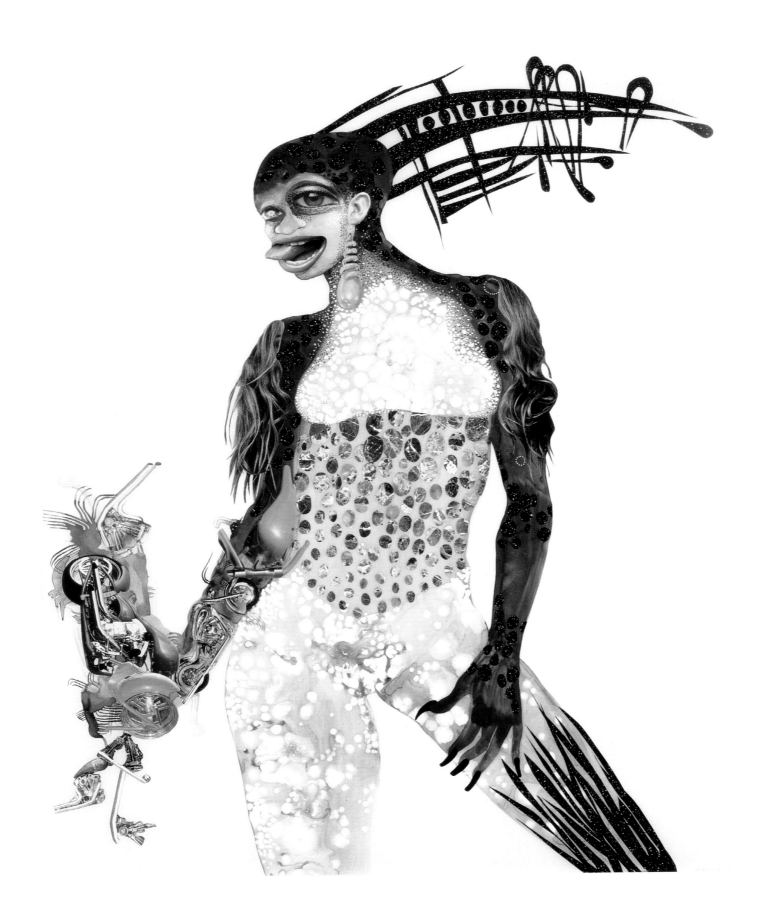

Double Fuse, 2003. Ink and collage on Mylar, 45" x 72"

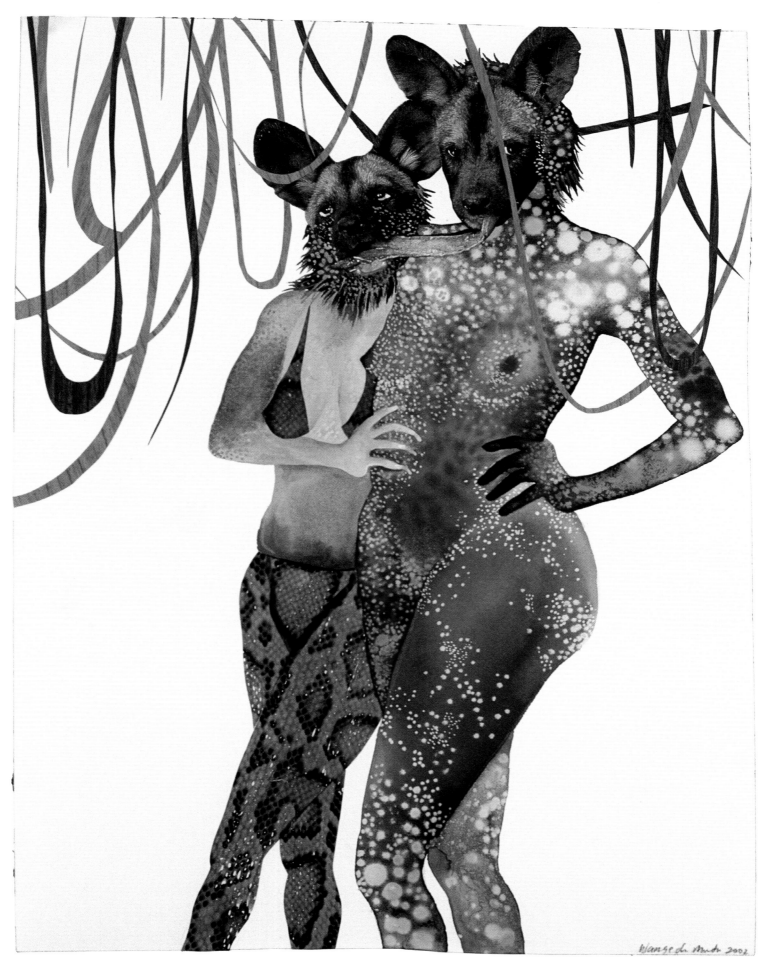

Intertwined, 2003, Ink and collage on Mylar, 20" x 16"

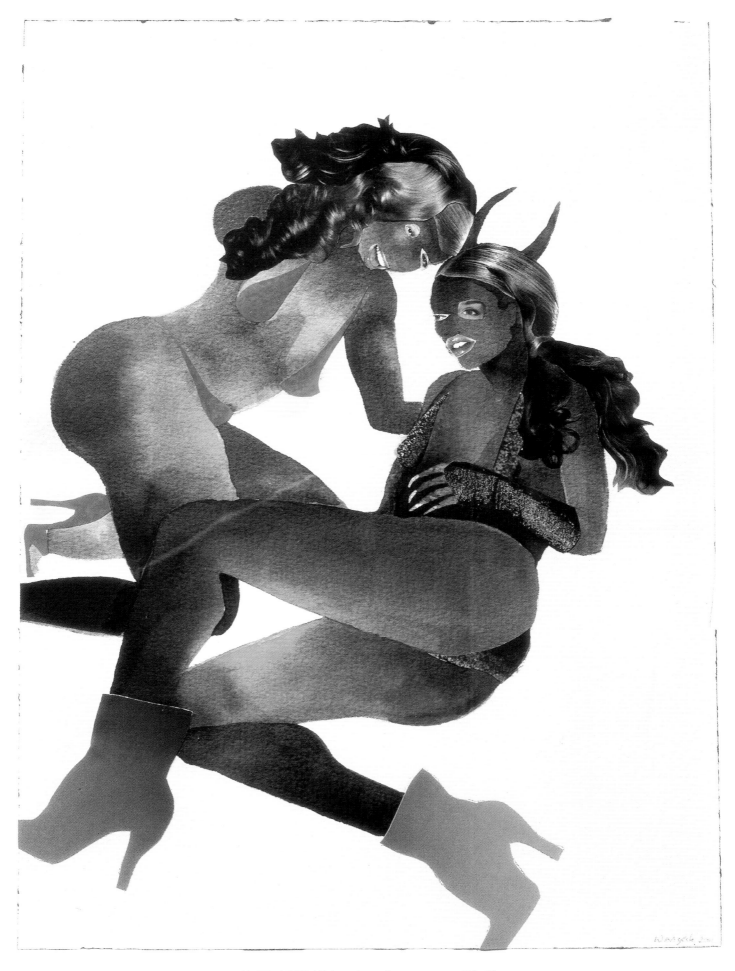

Untitled, 2001, Watercolor collage on paper, 12"x 9"

A Shady Promise

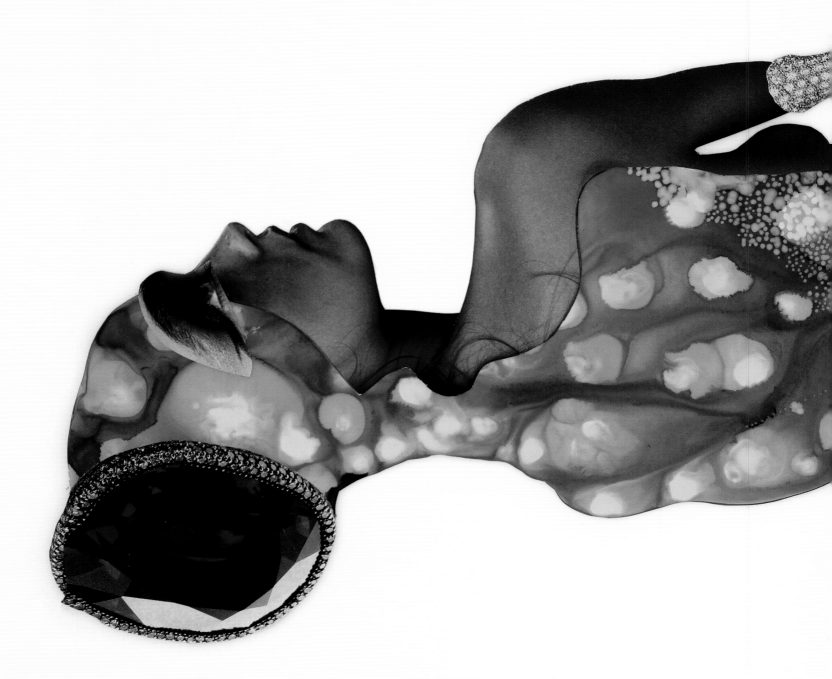

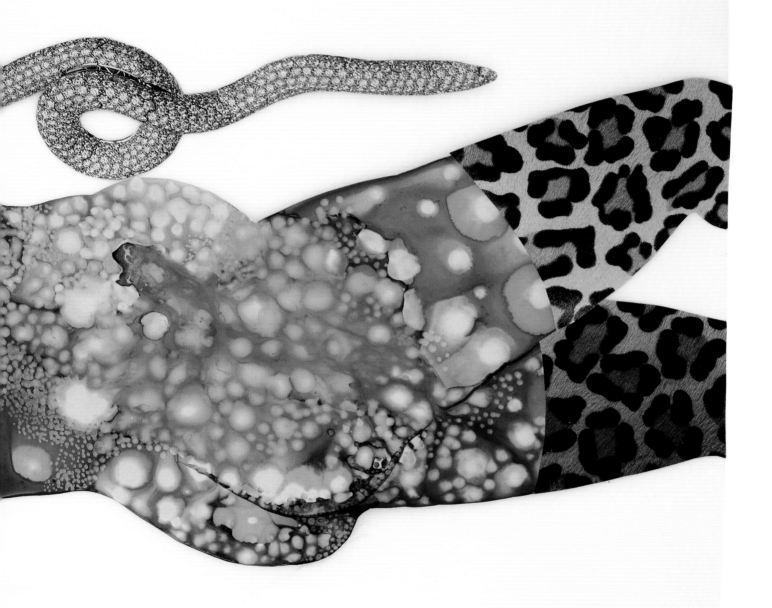

Untitled, 2002, Ink and collage on Mylar, 12" x 9"

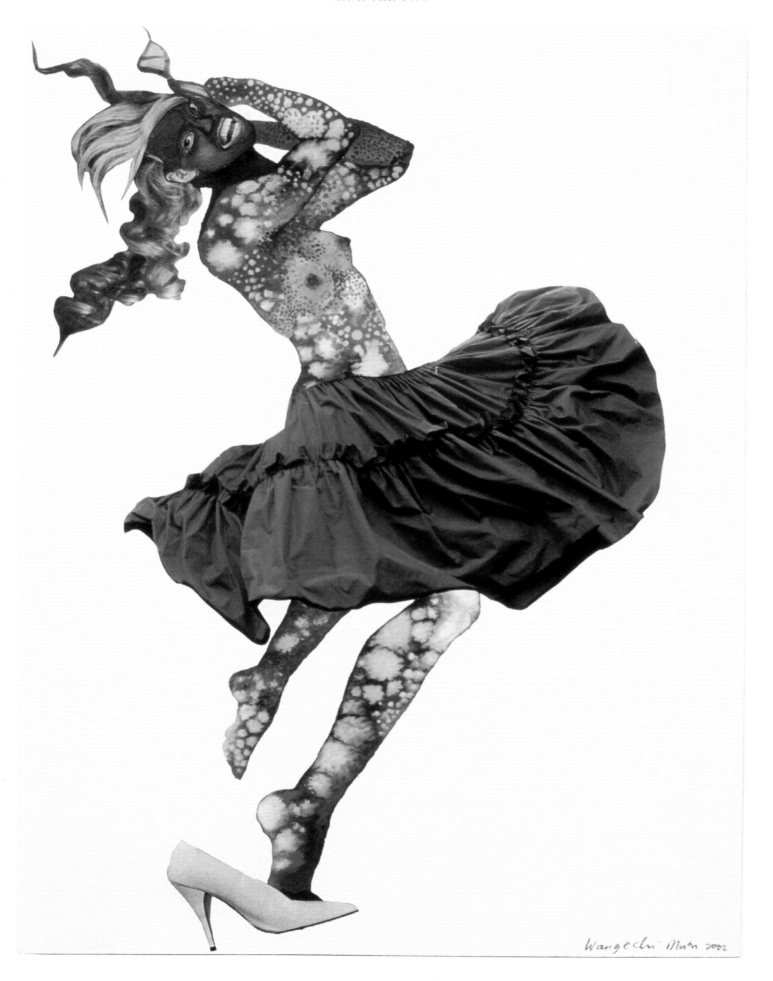

Untitled, 2002, Ink and collage on Paper, 17" x 22"

The individualism and self-determination of (black) women is often read as aggression, and is something that the world has trouble finding a place for. It is a characteristic, perceived of course as masculine, that many times has to be combined with the sensual or erotic (designated as feminine) in order to be understood. The impetus to unite these parts of the whole finds strange parallels in places where the erogenous abuts the violent.

—KELLIE JONES

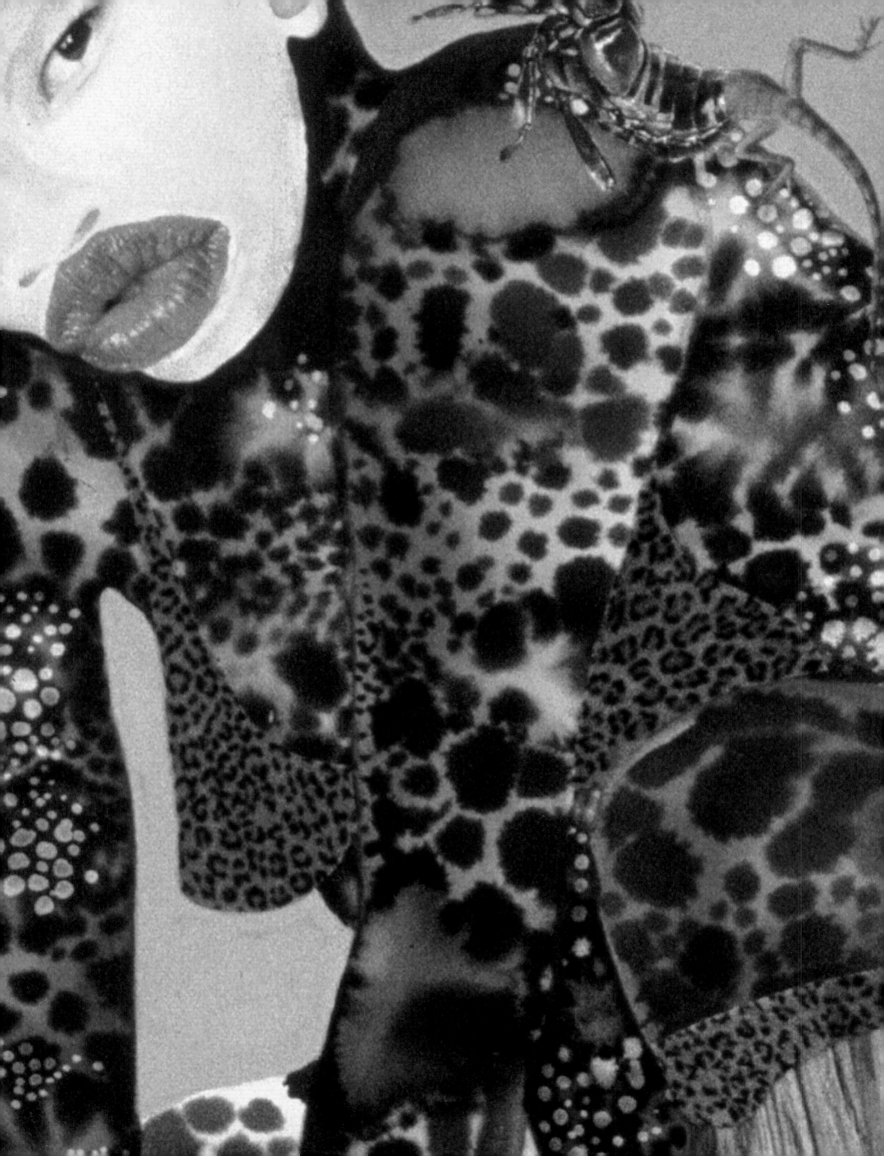

CHAPTER THREE

HYBRID

INTERVIEW

PART III: FIGURE SYMBIOTIC

Isolde Brielmeier with Wangechi Mutu

ISOLDE: *The figurative aspect of your work has been a constant. And many of your figures have taken on iconic significance. I am thinking of say, "Riding Death in My Sleep", or "Yo Mama", for example. Do these figures reference people in particular? Or certain communities or events? They seem both specific but also universal in a way.*

WANGECHI: Some of these figures stand for certain ideals and hopes that I feel are necessary to tackle shared challenges that stand in the way of "our" humanity, cultural understanding and coexistence. So for example, the figure in "Yo Mama" is this fierce, fictional planet-hopping warrior who is obviously traversing different histories and lands annihilating the huge serpent (as in the biblical snake, the phallus, a symbol of Christian patriarchy) with her heel. I try to express elements of female bravado and raise questions about ethnic identification whilst creating a mythological/futuristic character that confronts the lengthy history of these shared dilemmas. The stilettos appear often in my work, especially the collages. I have contradictory reasons for using them—they're weapons, prosthetics, embellishments, armor, and obviously, titillating power symbols. High heels are the quintessential heightening apparatus that constrains and deforms the body whilst functioning as an indicator of modernity, urbanization and "foreign" ideals of beauty. A work like "Riding Death in My Sleep" has a very similar emphasis on this mysterious, unknowable terrain where the subject is placed very central, including very carefully determined details of how she looks: her facial features, her pose, here garb—which could be confused for skin or a tight cat-suit. I was interested in this ethnically unrecognizable character whose body gesture is poking fun at the prevalent squatting pose used when photographing black women. There's still such an emphasis on racial profiling and the remnants of other forensic and cultural means of determining someone's racial identity from their face. It's one of those bogus sciences that has grown and coagulated into an institution of oppression and hierarchization. But I'm a big believer in putting an enticing trap leading myselfand the viewer towards a questioning, and perhaps understanding, of the definition of beauty.

INTERVISTA

PARTE III: FIGURE SIMBIOTICHE

Isolde Brielmeier con Wangechi Mutu

ISOLDE: *L'aspetto figurativo è stata una costante del tuo lavoro. E molte delle tue figure hanno assunto un valore iconico. Sto pensando, per esempio, a "Riding Death in My Sleep", o a "Yo Mama". C'è in loro un'allusione a qualcuno in particolare? O a una precisa collettività? O a degli eventi specifici? Sembrano avere, in qualche misura, un carattere particolare ma anche universale.*

WANGECHI: Alcune di queste figure rappresentano degli ideali e dei desideri precisi che credo siano necessari per affrontare le minacce condivise che ostacolano la "nostra" umanità, la nostra apertura culturale e la nostra coesistenza. La figura di "Yo Mama", per esempio, è una guerriera fiera e fantastica che, a balzi leggeri, attraversa manifestamente storie e terre diverse annientando sotto il proprio calcagno l'enorme serpente (il serpente biblico, il fallo, un simbolo del patriarcato cristiano). Tento di raccontare gli elementi della spacconeria femminile e di sollevare interrogativi sull'identificazione etnica, creando un personaggio mitologico/futuristico che affronti l'interminabile storia di tali dilemmi collettivi. Gli stiletto compaiono spesso nei miei lavori, soprattutto nei collage. Le ragioni per cui li utilizzo sono contraddittorie: sono delle armi, sono protesici, decorativi, sono un'armatura e, chiaramente, solleticano una simbologia del potere. I tacchi alti sono il tipico congegno "innalzante" che funge da indice di modernità, di urbanizzazione e di un ideale di bellezza "straniero". Un'opera come "Riding Death in My Sleep" pone un accento del tutto analogo su questo terreno misterioso e inconoscibile in cui il soggetto occupa una posizione di massima centralità e accoglie una descrizione attenta e minuziosa dei dettagli del suo aspetto: le caratteristiche del suo viso, la posa, l'abito, che potrebbe essere scambiato per la sua stessa pelle o per una tuta elasticizzata aderentissima. Ero incuriosita da questo personaggio etnicamente non riconoscibile, la cui gestualità ridicolizza la posa accovacciata comunemente usata nel fotografare le donne nere. Si dà ancora moltissima importanza al *racial profiling* e agli avanzi di quegli strumenti forensi e culturali che determinano l'identità razziale di una persona a partire dal suo viso. È una di quelle scienze fasulle che sono cresciute e si sono rapprese nell'istituzione dell'oppressione e della gerarchizzazione. Ma credo fermamente nel valore di una trappola seducente che conduca me e lo spettatore verso una contestazione e, forse, verso una comprensione della definizione di bellezza.

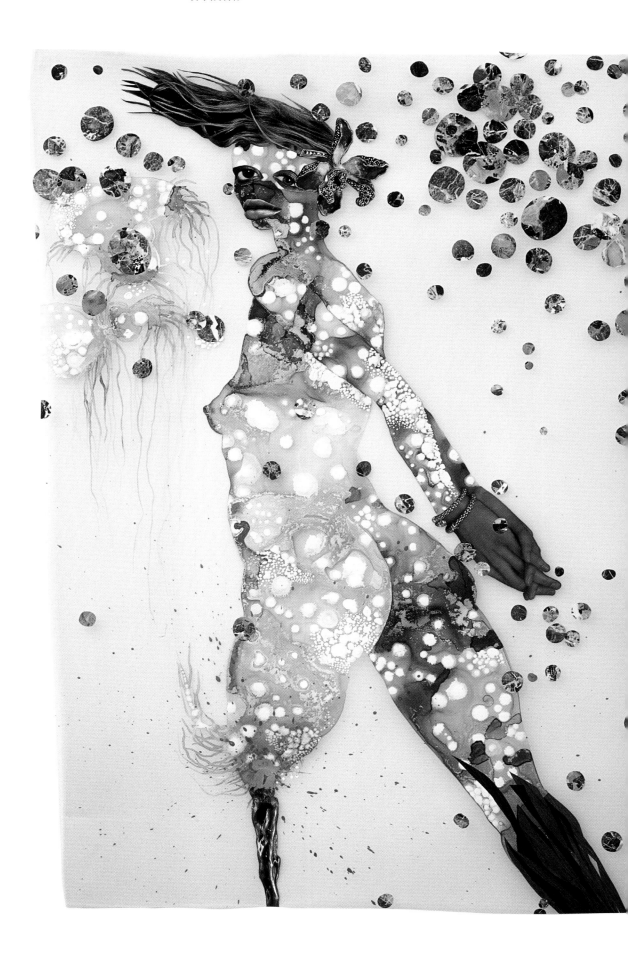

I Have Peg Leg Nightmares, 2003, Collage and watercolor on Mylar, 43 ¹/₂" x 30"

A Shady Promise

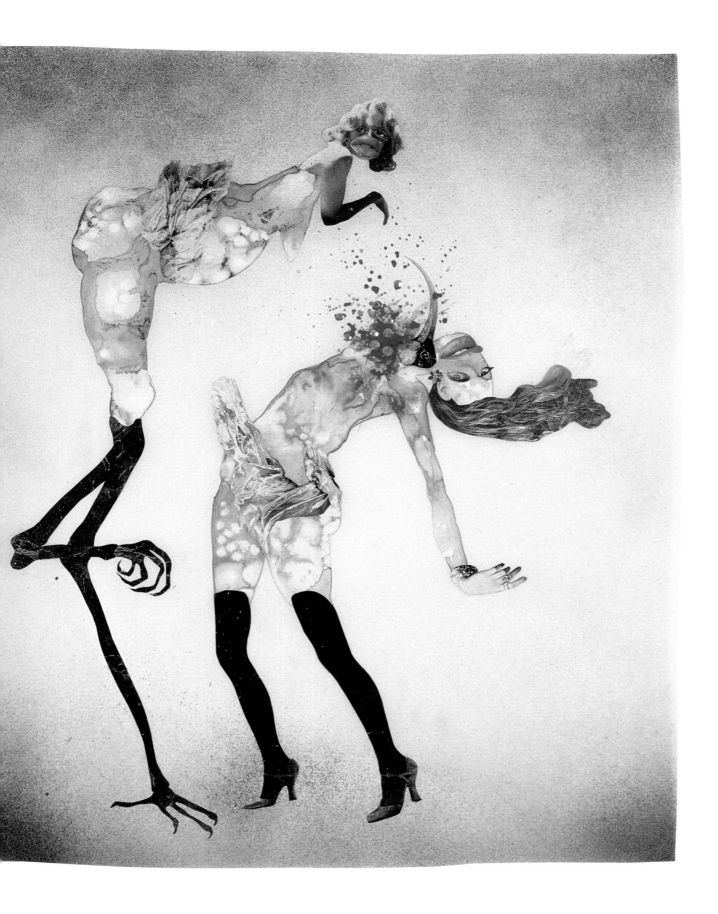

Split, 2004, Ink, collage, spray paint on Mylar, 28" x 23"

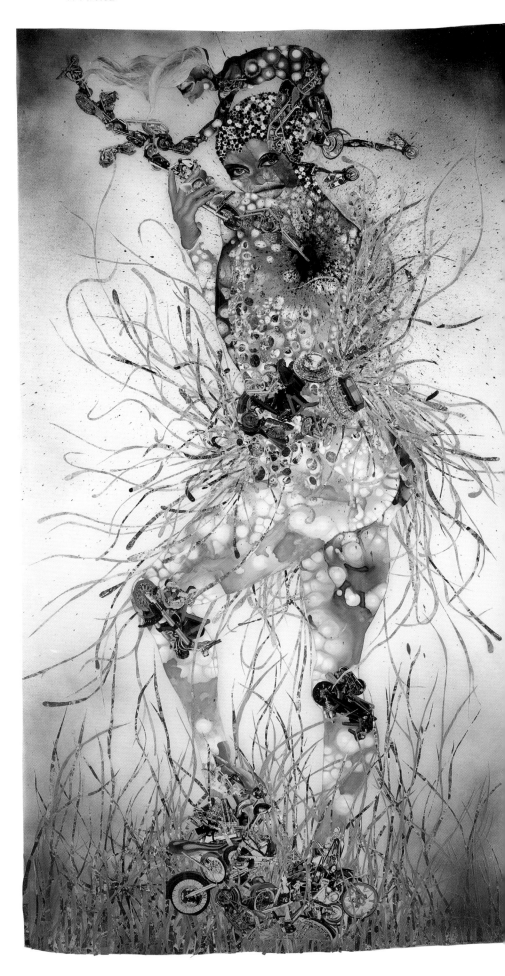

How To Stab Oneself In The Back, 2004, Mixed media, ink, collage on Mylar, 76" x 42"

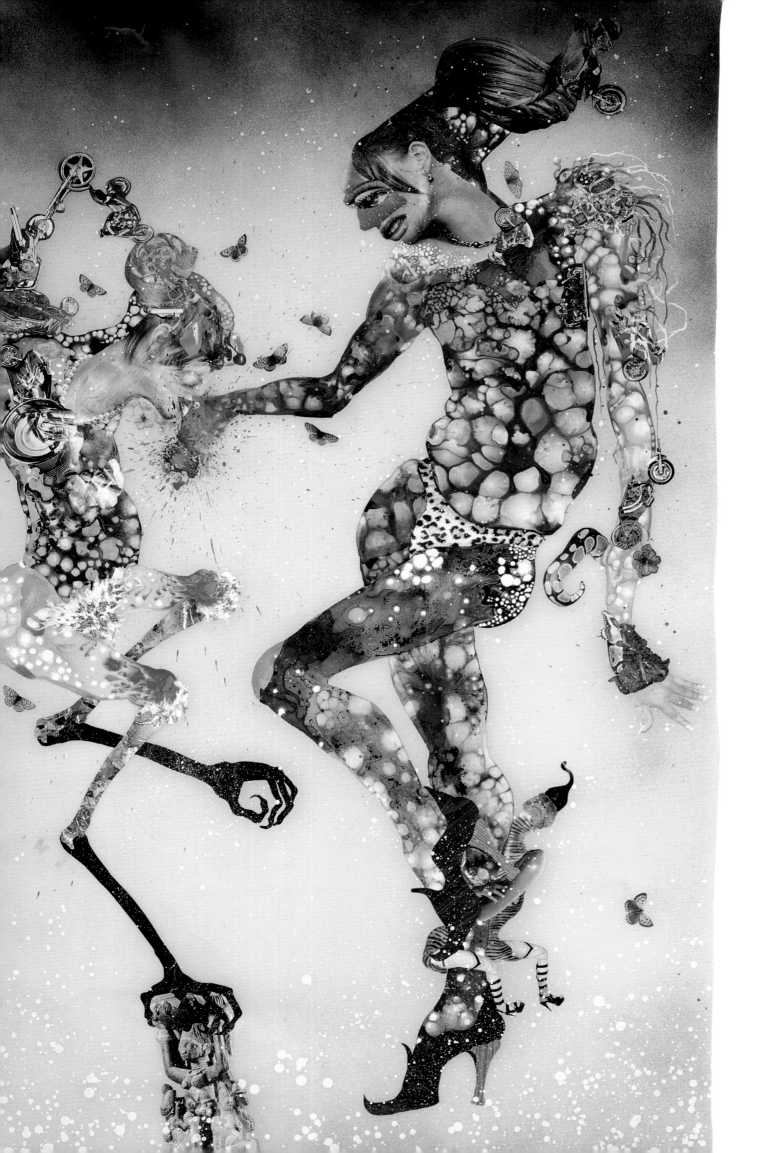

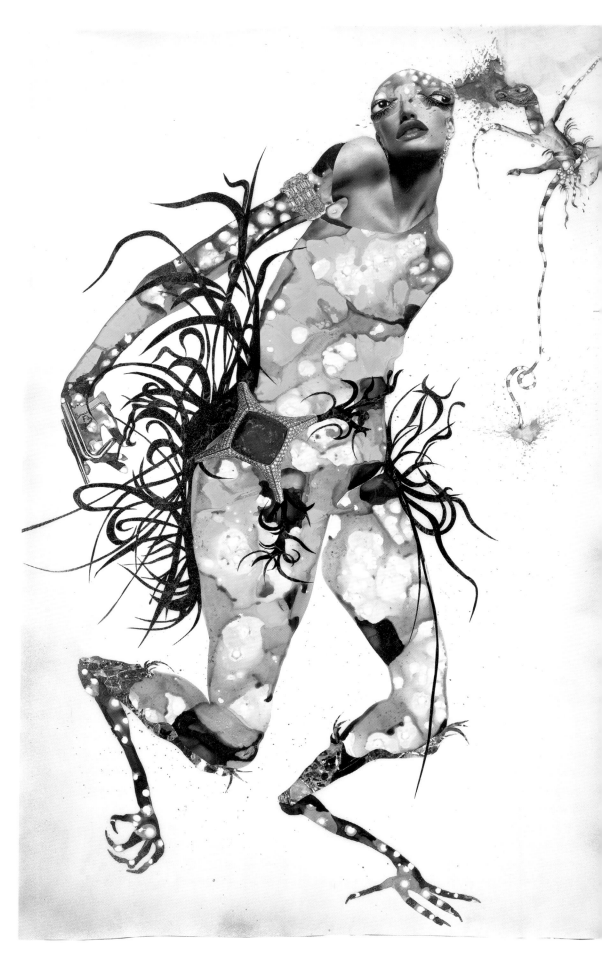

LEFT: *The Patrician's New Curse*, 2004, Ink, acrylic, collage and contact paper on Mylar, 66 ¹/₂" x 40"
ABOVE: *I Shake a Tail Feather*, 2003, Ink, collage on Mylar, 66" x 42"

A Shady Promise

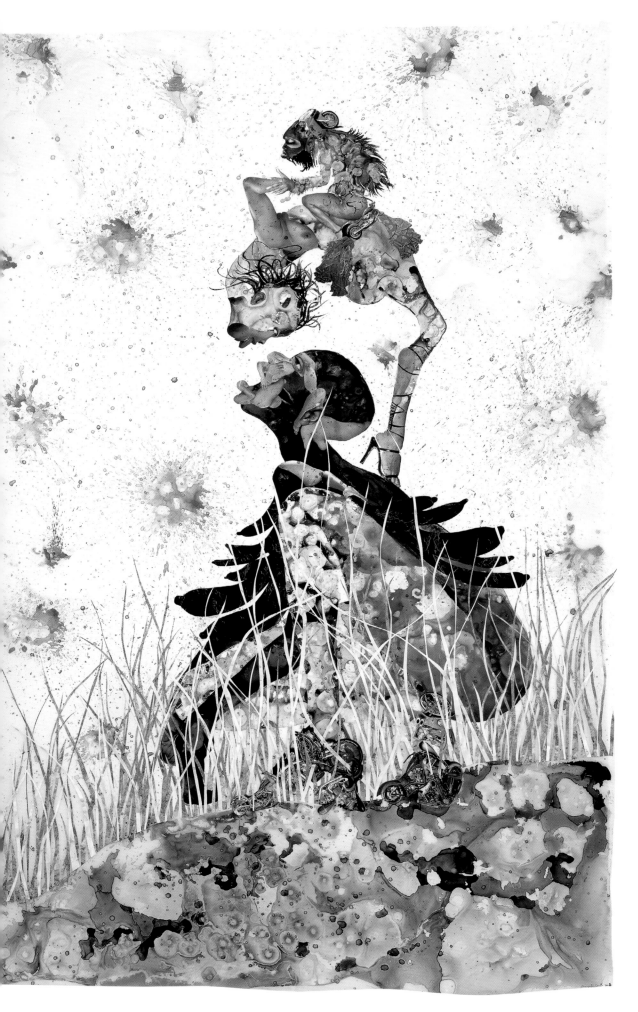

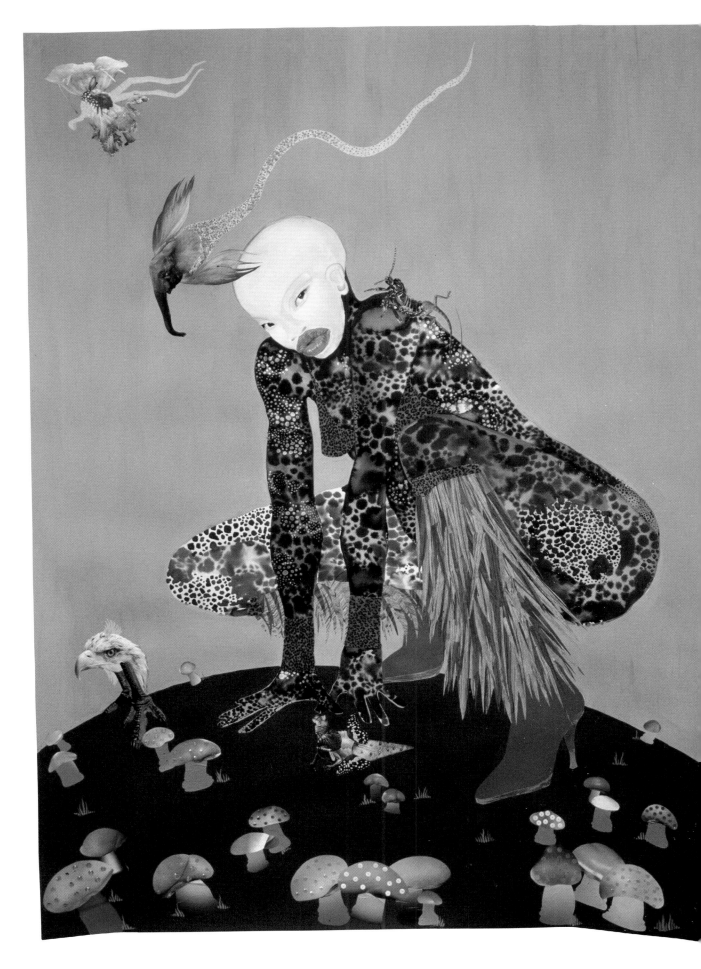

LEFT: *Misguided Unforgivable Hierarchies*, 2005, Ink, acrylic, collage and contact paper on Mylar, 81" x 52"
ABOVE: *Riding Death in My Sleep*, 2001, Ink and collage on paper, 60" x 44"

A Shady Promise

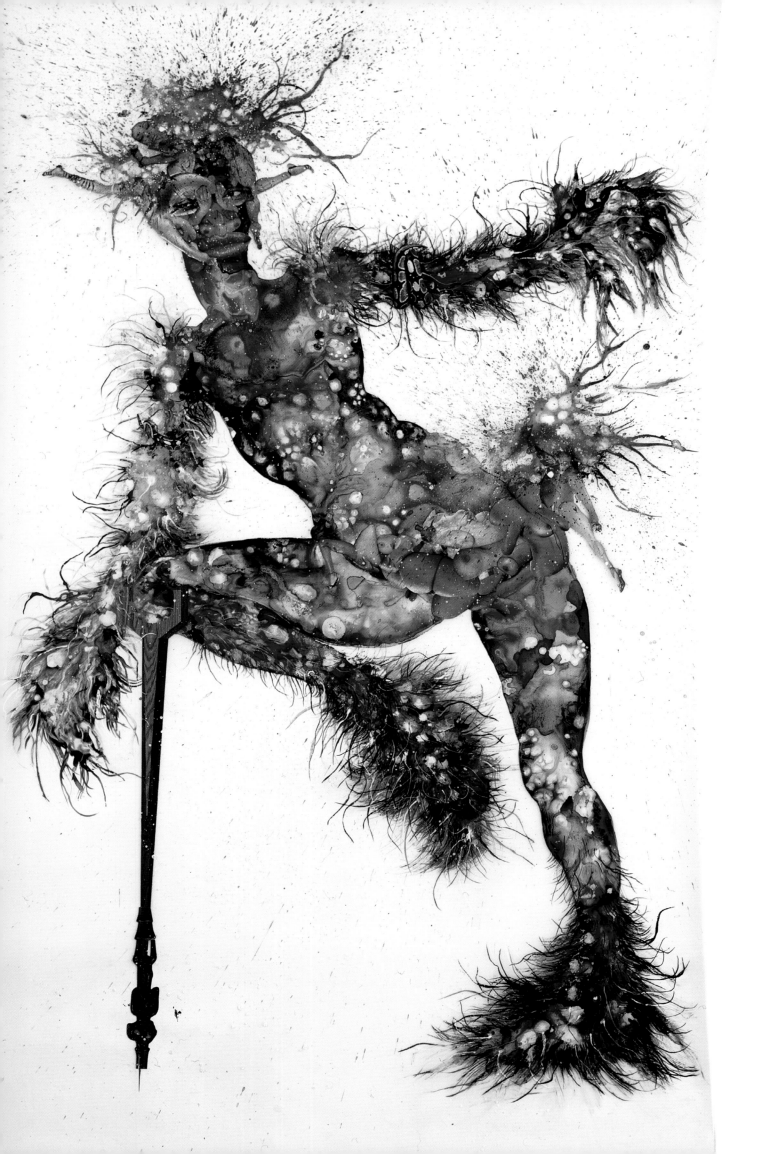

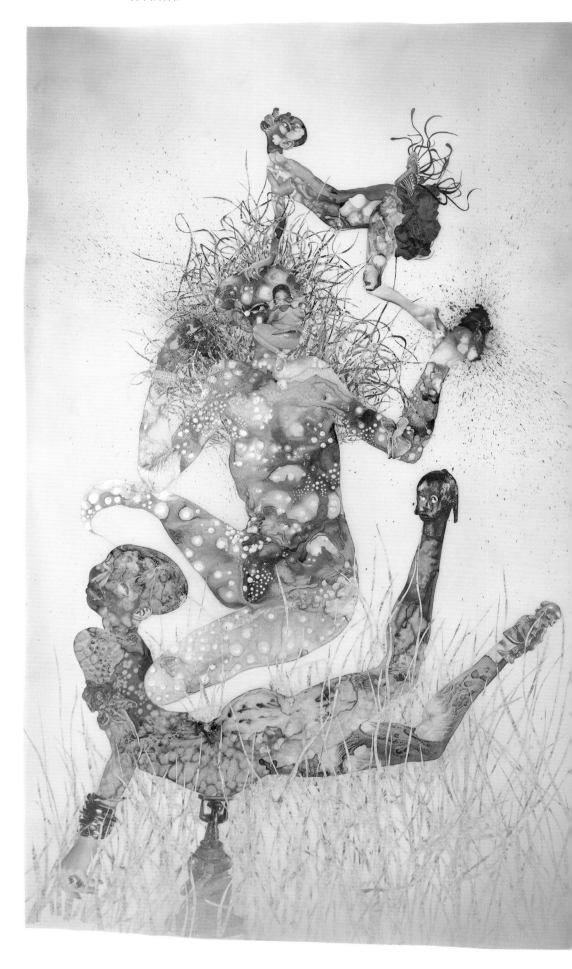

LEFT: *She's Egungun Again*, 2005, Ink, acrylic, collage and contact paper on Mylar, 87" x 52 ¹/₂"
ABOVE: *Sleeping Sickness Saved Me*, 2005, Mixed media on Mylar, 86" x 51¹/₂"

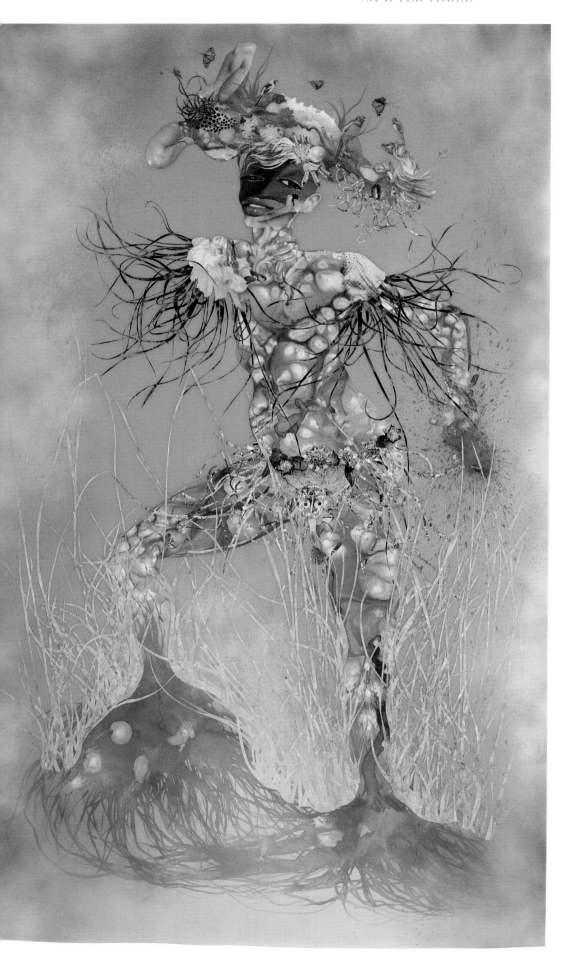

ABOVE: *Me Carry My Head on My Home on My Head*, 2005, Ink fur acrylic glitter on Mylar, 88 $\frac{1}{4}$" x 51 $\frac{3}{4}$"
RIGHT: *Le Noble Savage*, 2006, Ink, collage on Mylar, 91 $\frac{3}{4}$" x 54"

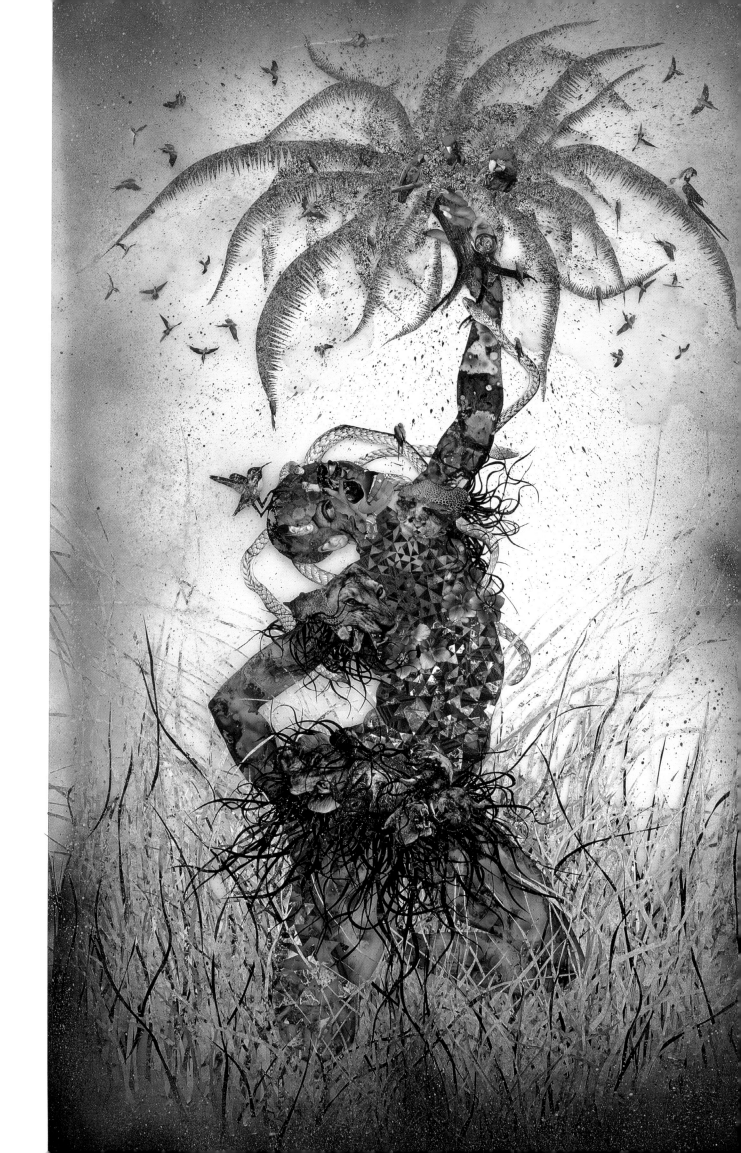

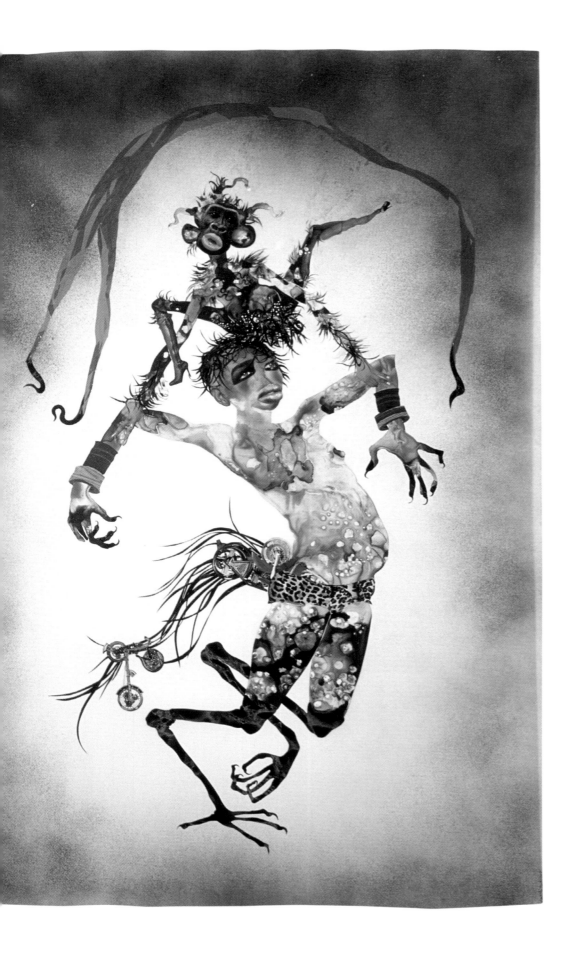

ABOVE: *I Put a Spell on You*, 2005, Ink, acrylic, collage, contact paper and packing tape on Mylar, 81" x 52"
RIGHT: *A Fake Jewel in the Crown*, 2007, Mixed media, ink, collage on Mylar, 89" x 54"

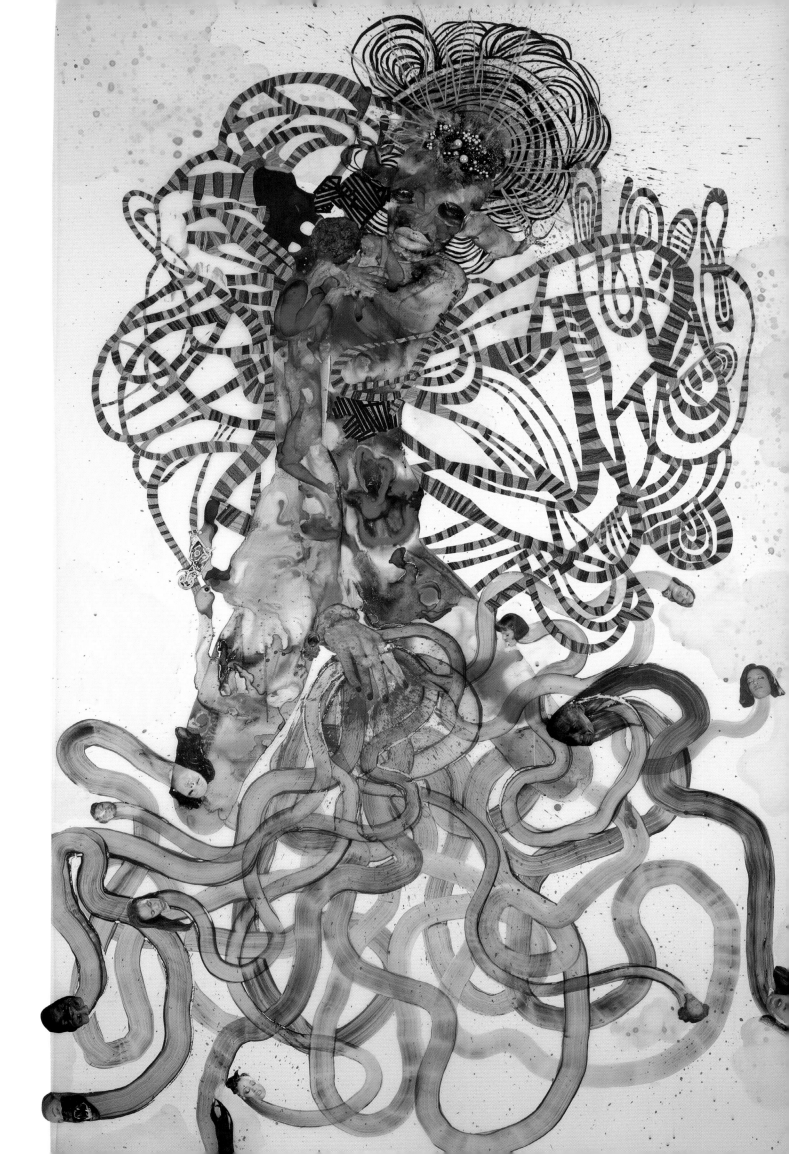

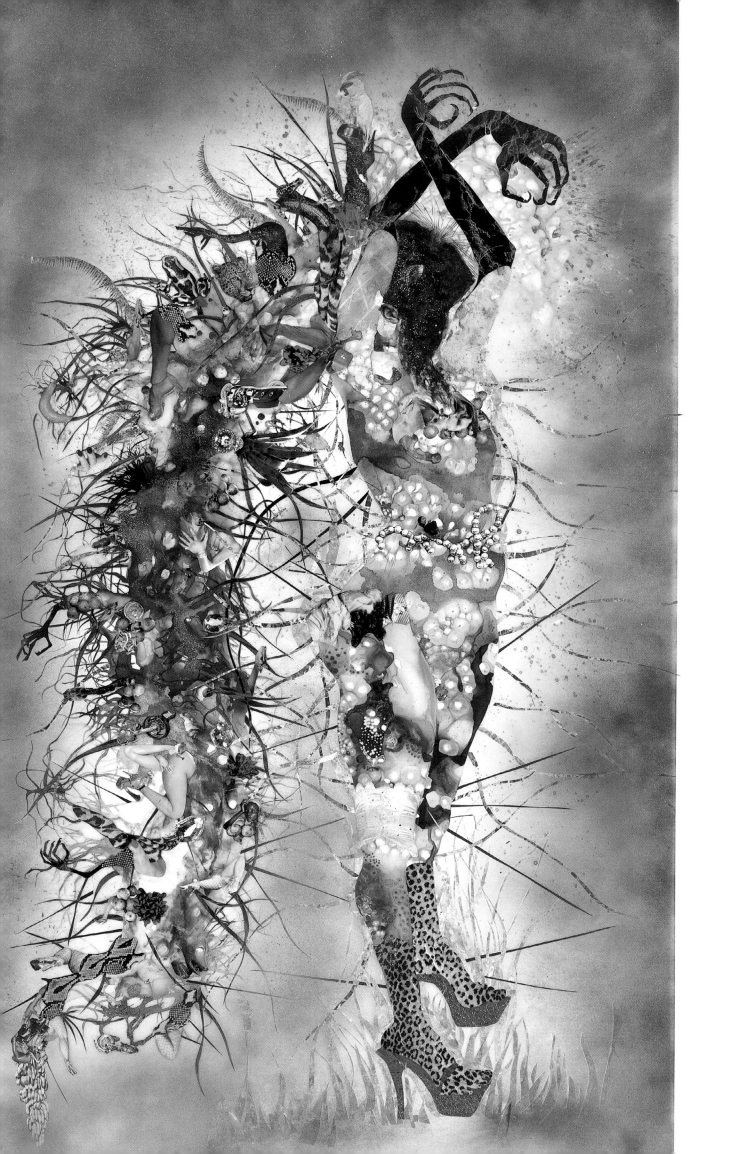

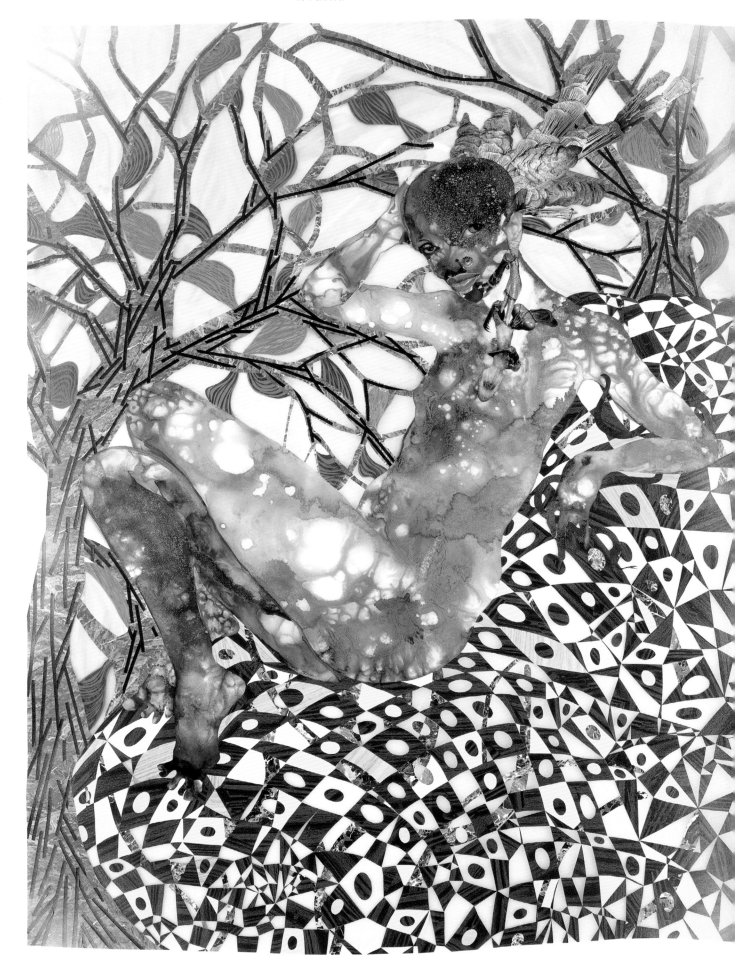

LEFT: *Lockness*, 2006, Mixed media, ink, collage on Mylar, 95 ¹/₄" x 54" ABOVE: *Preying Mantra*, 2006, Mixed media on Mylar, 73 ¹/₄" x 54 ¹/₄"
NEXT SPREAD: *A Shady Promise*, 2006, Mixed media on Mylar, 87 ¹/₂" x 108 ³/₄"

A Shady Promise

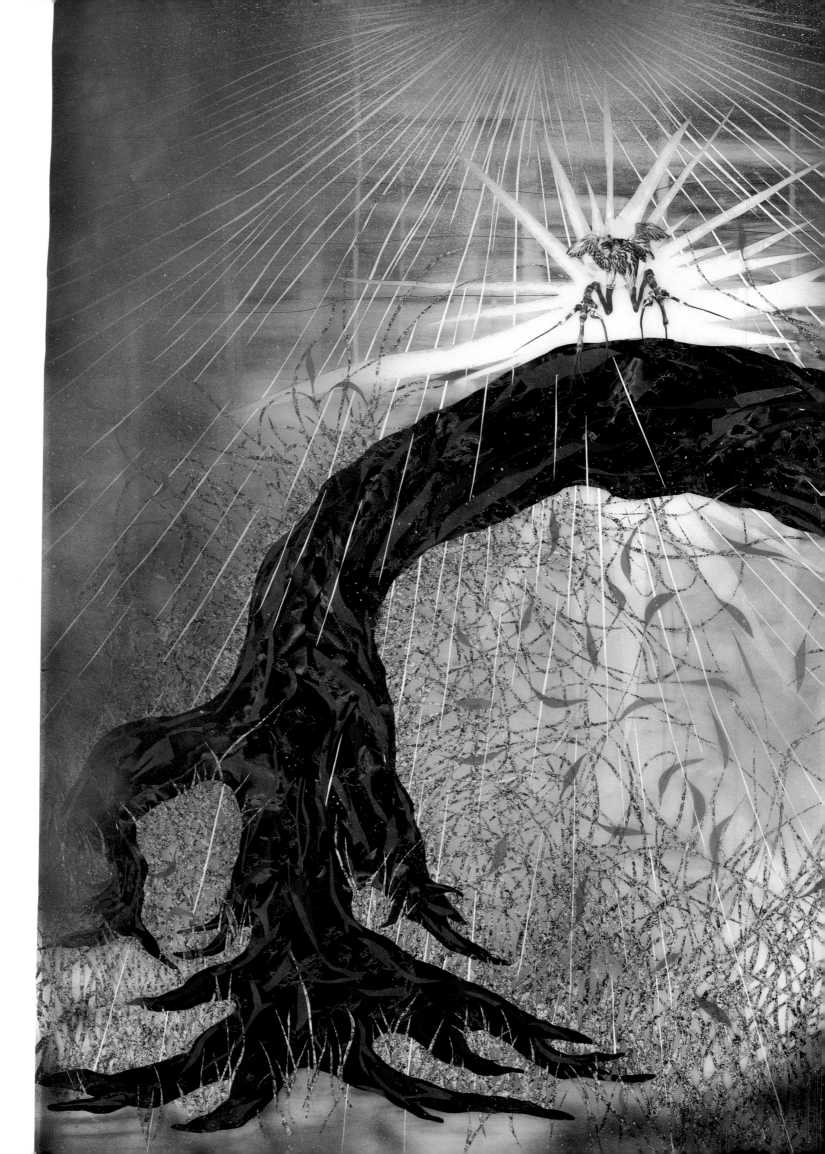

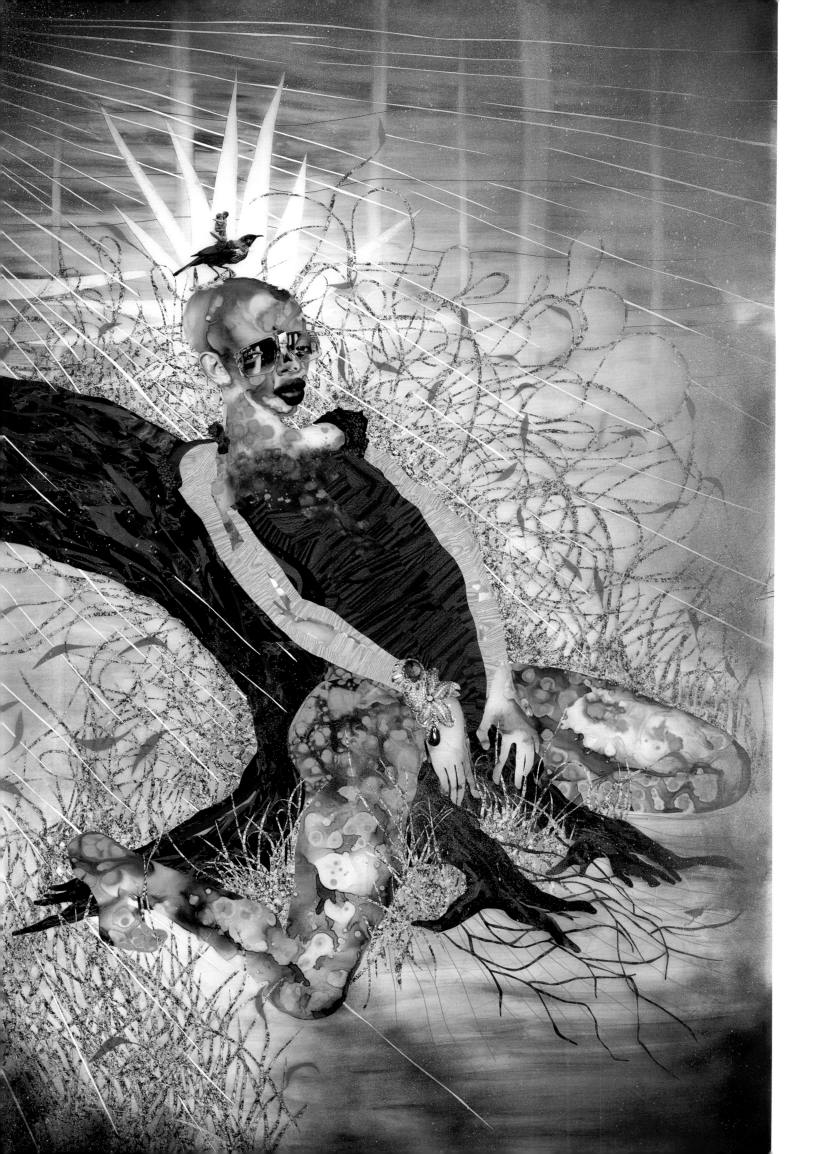

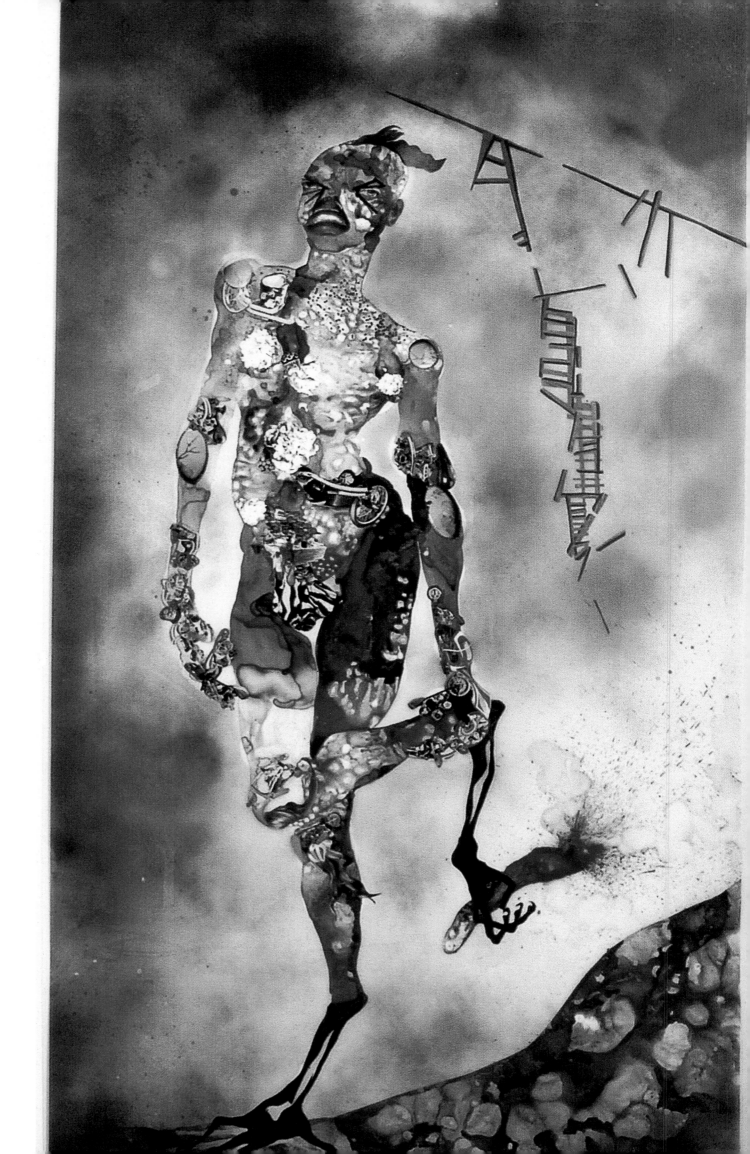

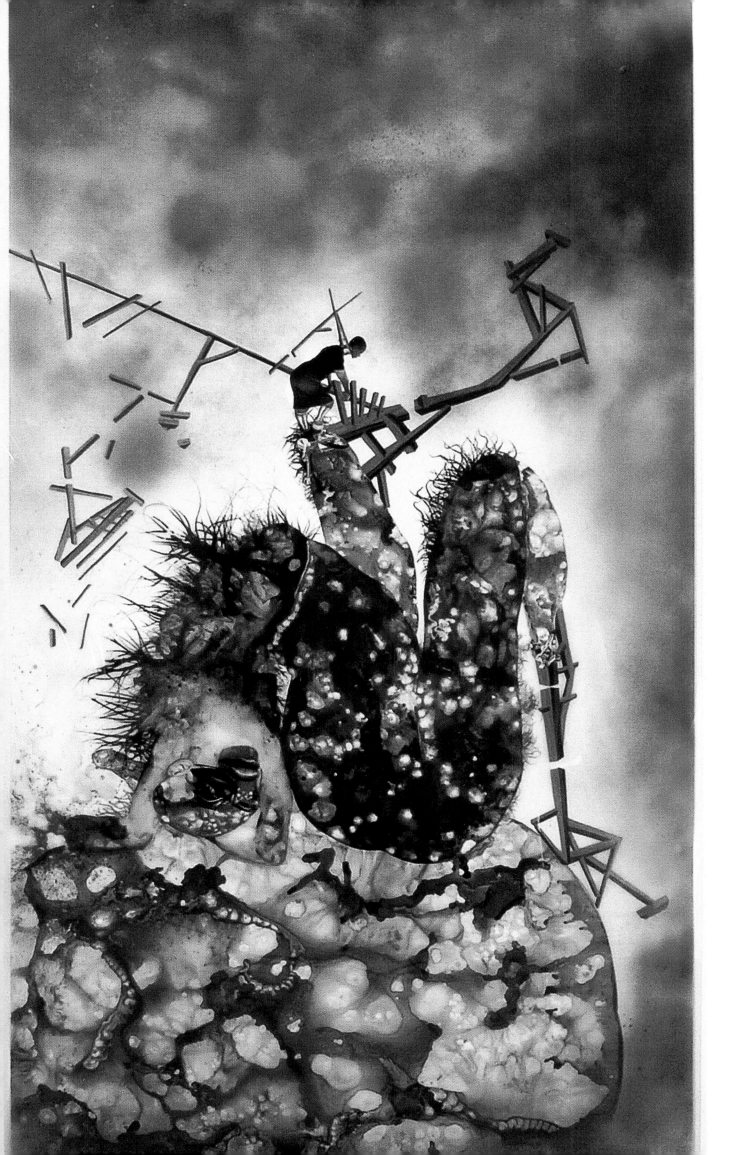

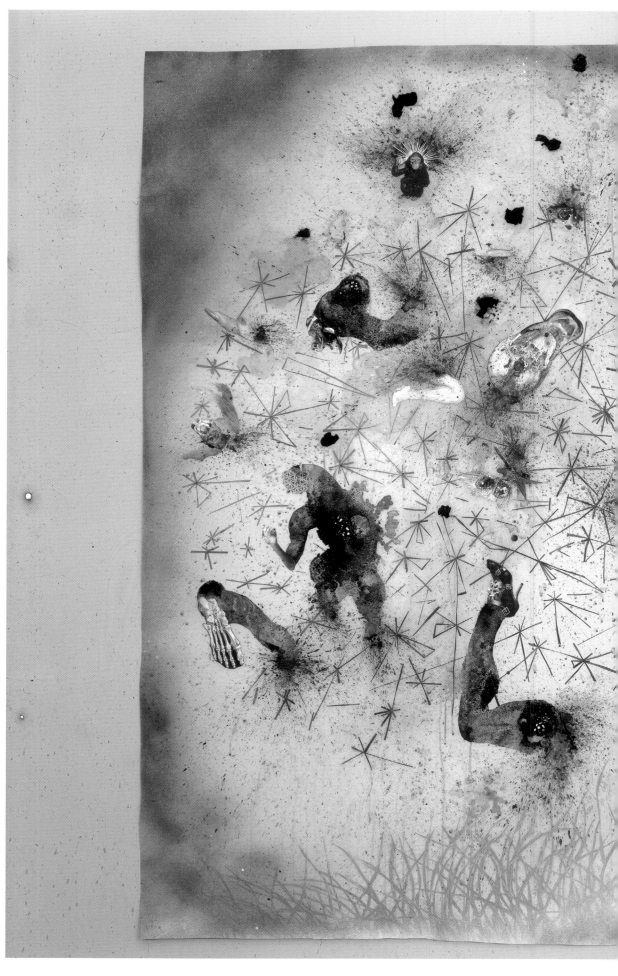

PREVIOUS SPREAD: *My Strength Lies*, 2006, Ink, acrylic, collage and contact paper on Mylar, 90" x 108"

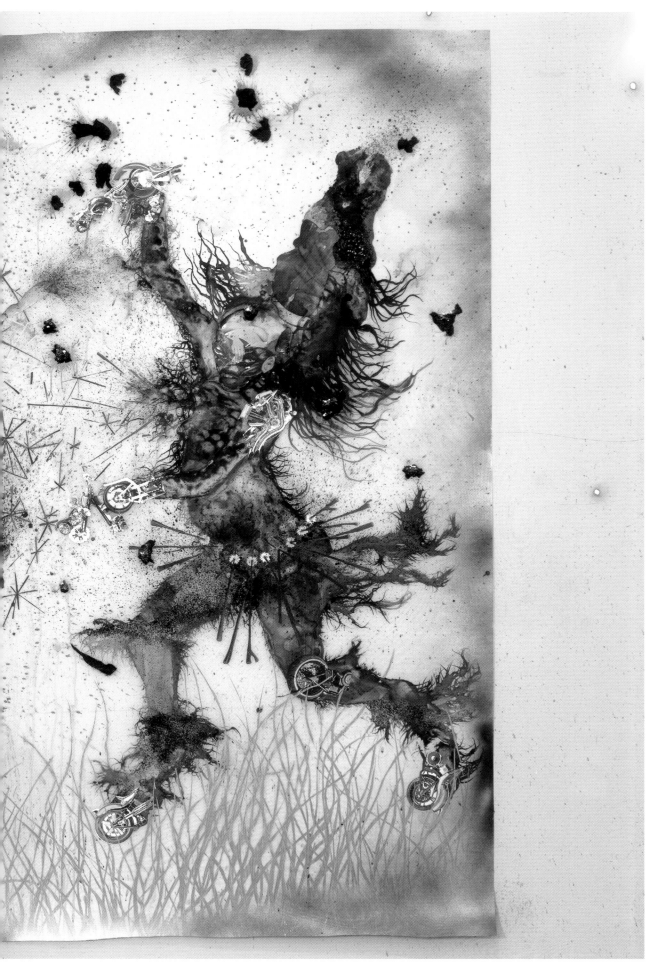

ABOVE: *Try Dismantling the Little Empire Inside of You*, 2007, Ink, acrylic, collage on Mylar, 97" x 107"

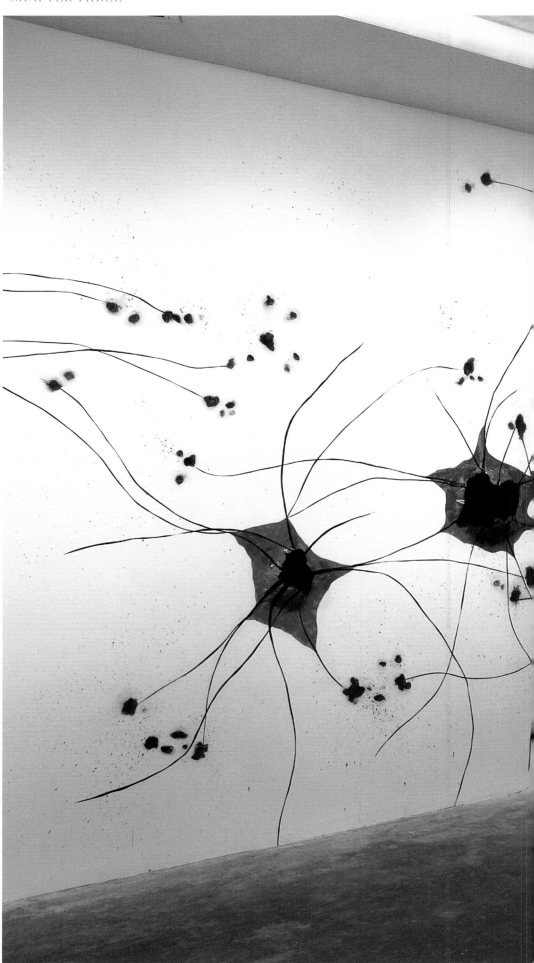

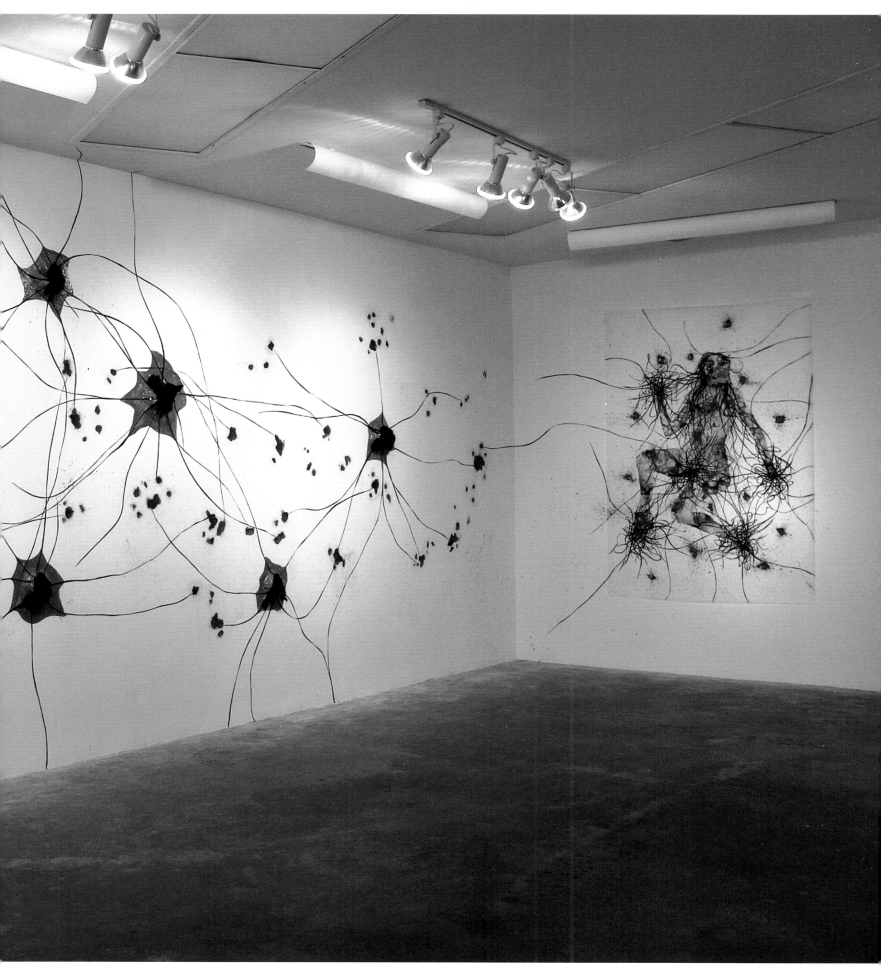

Erasing Infestation—An Exercise in Historical Futility, 2005, Mixed Media, Dimensions variable

A Shady Promise

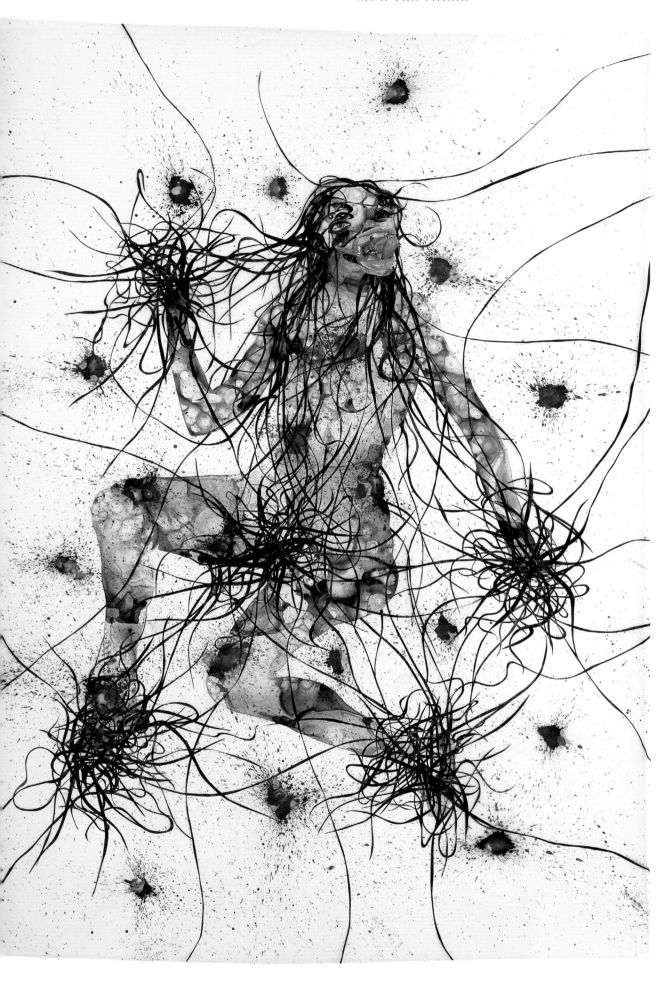

Royal Blue Arachnid Curse, 2005, Ink, acrylic, collage and contact paper on Mylar, 77 $^1/_2$" x 51 $^1/_2$"

"Marcus" says:

These outer images of ultimate otherness
These symbols and diagrams of hate
These cathartic pleasurable violences
That inner matrix of lies
This chasm of ecstasy
Of faith and design

Aghast this map points me
Here in the desired aftermath of the aftershock
This East, the direction with no end

Beyond the hemorrhaging
Where I reside

I sing this hymn for punctuation and surprise
That awkward melody
Was her reply

The treasures you seek
This "inflection" dominion determines just us
Return release

This zone erodes erogenous
Strap your goggles
Let's go!

I'm dangling
I am a tongue
And oh so detrimental
The optic refrain
Coopted sponge culture code
run run

Restated:
So Don't,
Who's behind the gauzed gaze?

I'm doctor, lawyer and capitano/clergy
This fever, the organ, coo coup "krak attack"
She is steering

Her power divines the graph
This impunity of prophetic memories
This immeasurable membrane, the unhome where I reside

Where I reside

—GIUILLERMO BROWN

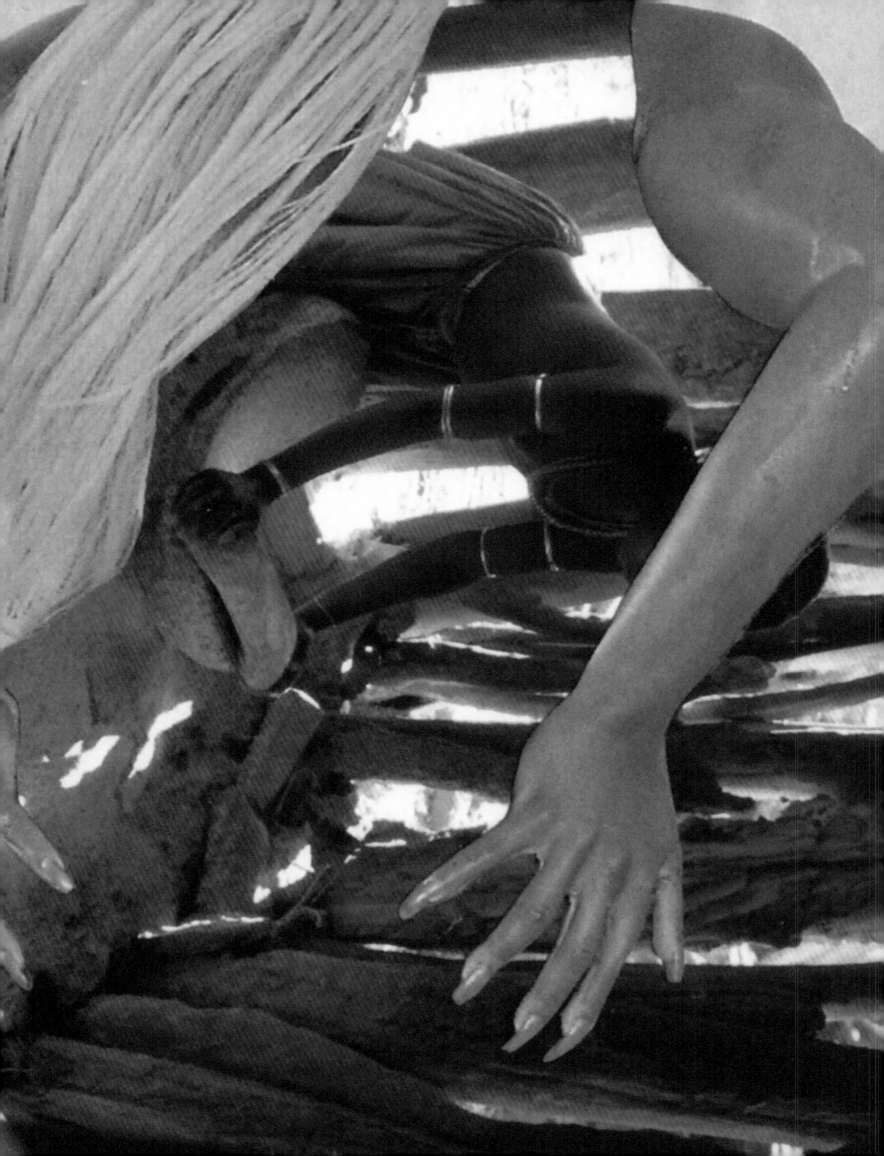

CHAPTER FOUR
BODY AS SPACE

INTERVIEW

PART IV: SPACE WANDER

Isolde Brielmeier with Wangechi Mutu

ISOLDE: *I am thinking back to one of our many conversations and how you mentioned that as you've grown as an artist you have gained more confidence in how you work, and in how and when you choose to move off the "canvas" and out into the world of spaces. Can you speak a bit more about your more recent installations and the idea of the body "becoming space"? Does the white cube actually become a metaphor for "woman" in much of your work?*

WANGECHI: The body in my work is a point of departure for me. So when I began manipulating and scarring, marking and hammering the walls of the gallery, I was dealing with my own frustrations and feelings of confinement. My body became an extension of the mark-making tool and I began to create a permanent reminder of this inner rage that probably emanated from feeling uncomfortable as a foreigner in the United States in a time of war and xenophobia. When I began to make bullet wounds I was at a residency in San Antonio, Texas, trying to find a way to think and make work that allowed me to express my sentiments about the border, about environmental destruction, about waste and human conflict. The walls turned into a huge skin surface and the floors became stained with the dripping fluid from almost two-dozen bottles of wine. The space felt, and smelt, more alive with each passing day. The scent went from rancid wine to a yeast and baking bread odor. I wasn't thinking about a specific gender but it did seem to feel somehow more female. Incidentally, a very well respected doctor came by my installation and he was very interested in the "wounds" and in fact he diagnosed them saying that if a patient had walked in with these kinds of wounds he would say they were self-inflicted wounds, because they're deeper in the center of the laceration and numerous in number, a sign of a compulsive, monotonous puncturing. Given that I intended them to be marks hacking onto the institution wall, I thought what a fascinating reversal that was; in actual fact they may have been on a deeper level a hurting of myself. Recently I have stopped working with these wall punctures because ironically I did injure myself whilst creating them. The result has been a very important departure for me conceptually and of course materially. The work *Will Honey Flavoured Milk Soften That Pig Fed Rage?* is a recent manifestation of a new direction still dealing with the body as space and space/land as shared body.

INTERVISTA

PARTE IV: SPACE WANDER

Isolde Brielmeier con Wangechi Mutu

ISOLDE: *Ripensavo ad una delle nostre tante conversazioni e a come avessi accennato alla tua crescita artistica come elemento che ti è valso una maggiore sicurezza verso il tuo modo di lavorare e verso le modalità e i tempi della tua scelta di allontanarti dalla "tela" per calarti nell'universo degli spazi. Puoi dirci un po' di più sulle installazioni più recenti e sull'idea del corpo che "diventa spazio"? In molta parte del tuo lavoro, il cubo bianco diventa essenzialmente una metafora della "donna"?*

WANGECHI: Nel lavoro il corpo è per me un punto di partenza. Quando ho iniziato a manipolare, sfregiare, marchiare e martellare le pareti della galleria, mi stavo misurando in realtà con le mie frustrazioni e con il mio senso di prigionia. Il mio corpo è diventato un prolungamento dell'arnese con cui lasciavo quei segni e ho cominciato a dare vita ad un continuo richiamo a questa rabbia interiore che probabilmente nasceva dal disagio che, in un periodo contrassegnato da guerra e discriminazione, vivevo come straniera negli Stati Uniti. Quando iniziai a fare ferite da proiettile mi trovavo in un'abitazione a San Antonio, in Texas, e tentavo di trovare un modo per pensare e realizzare del lavoro che mi consentisse di esprimere i miei sentimenti riguardo la marginalità, la devastazione ambientale, lo spreco e il conflitto umano. Le pareti si sono tramutate in un'enorme superficie epidermica e i pavimenti si sono macchiati del fluido che gocciolava da quasi due dozzine di bottiglie di vino. Questo spazio sentiva e odorava in maniera ogni giorno più vigorosa. L'odore andava da quello del vino rancido a quello del lievito e del pane che cuoce. Non stavo pensando ad un genere specifico, ma si avvertiva in qualche modo una preponderanza del femminile. Casualmente, un medico molto stimato venne a vedere l'installazione. Era molto interessato alle "ferite", che di fatto esaminò clinicamente, sostenendo che se gli si fosse presentato un paziente con tali ferite, le avrebbe senz'altro considerate autoinflitte, perché sono più profonde, si trovano al centro della lacerazione e sono numerose, segno di una perforazione compulsiva e ripetuta. Considerando che volevo realizzare segni capaci di fendere in profondità il muro dell'istituzione, pensai a quale incantevole rovesciamento questo fosse; ad un livello più profondo, essi potevano configurarsi, in realtà, come un danno inflitto alla mia stessa persona. Recentemente ho smesso di lavorare con i fori nei muri perché proprio facendoli, ironicamente, mi sono fatta male. Il risultato è stato un distacco per me di grandissima importanza sia concettualmente che, senza dubbio, materialmente. *Will Honey Flavoured Milk Soften That Pig Fed Rage?* è l'esito recente di una nuova direzione che ha ancora a che vedere con il corpo in quanto spazio e con lo spazio/terra come corpo condiviso.

ABOVE: *The Ark Collection*, Vitrine, 2006, Dimensions Variable, Sikkema Jenkins Gallery
FOLLOWING TWO SPREADS: *The Ark Collection*, 2006, 6 1/$_2$" x 9 1/$_2$", Sikkema Jenkins Gallery

A Shady Promise
121

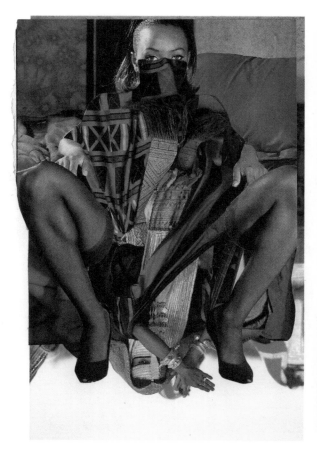

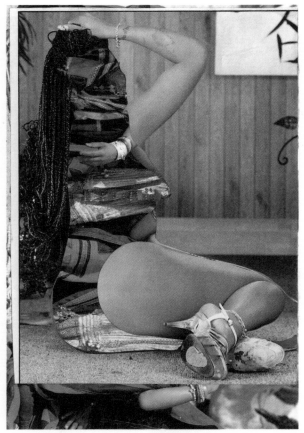

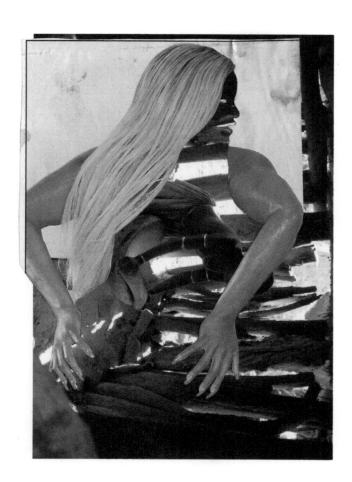

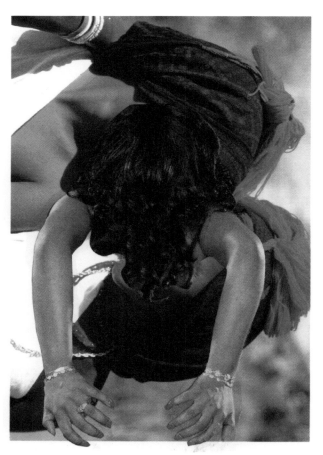

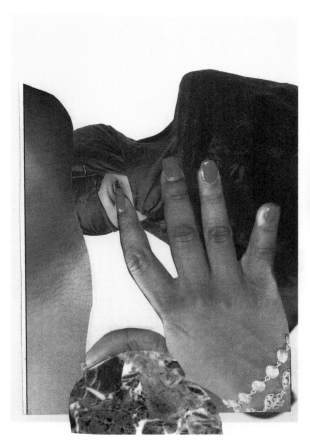
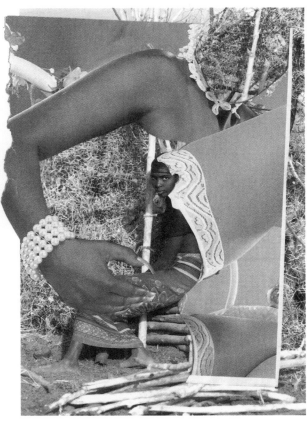
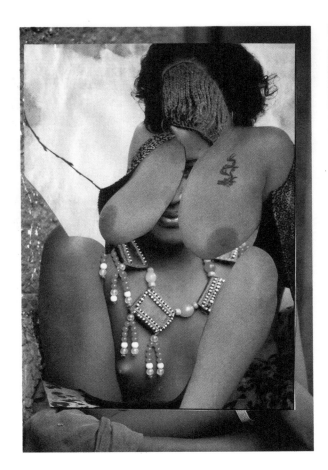
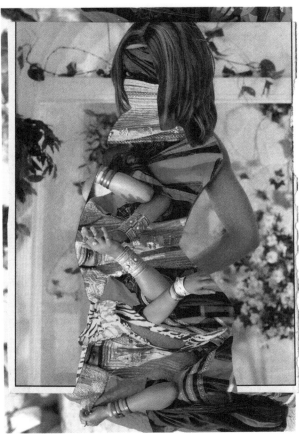

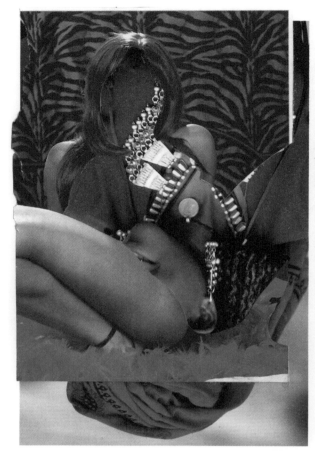
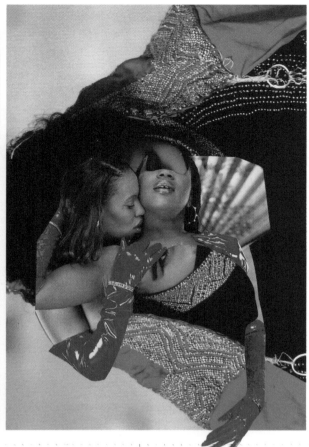
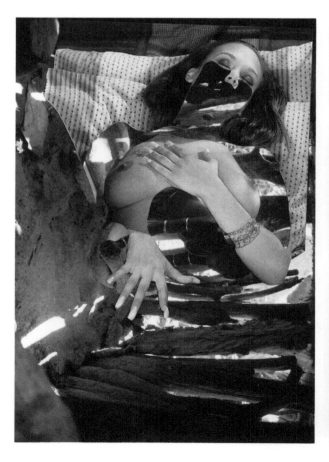
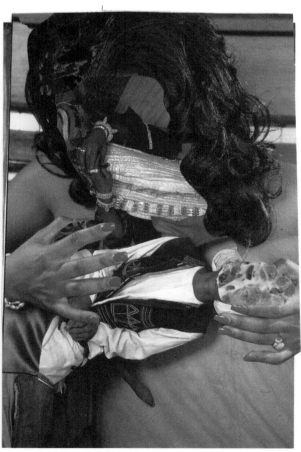

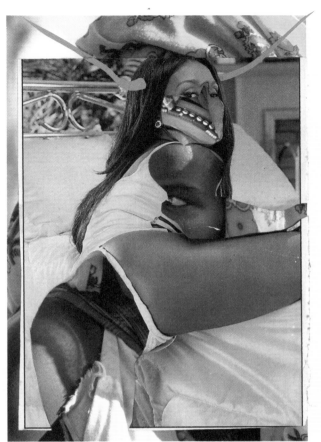

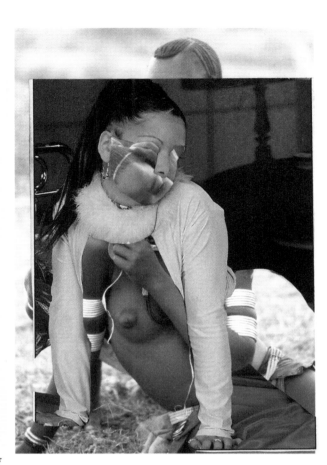

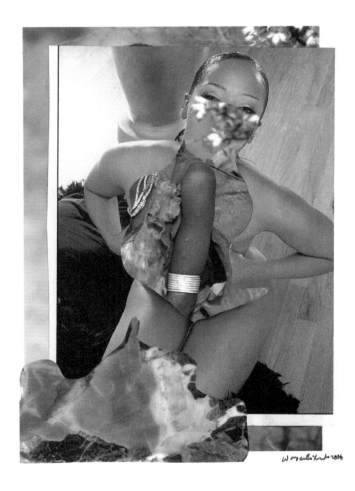

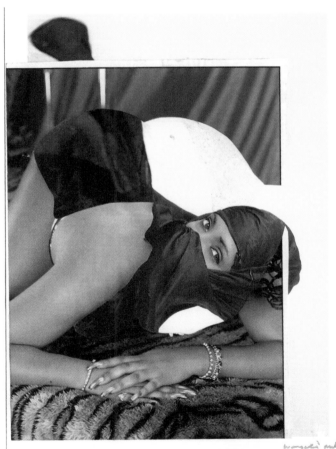

A Shady Promise

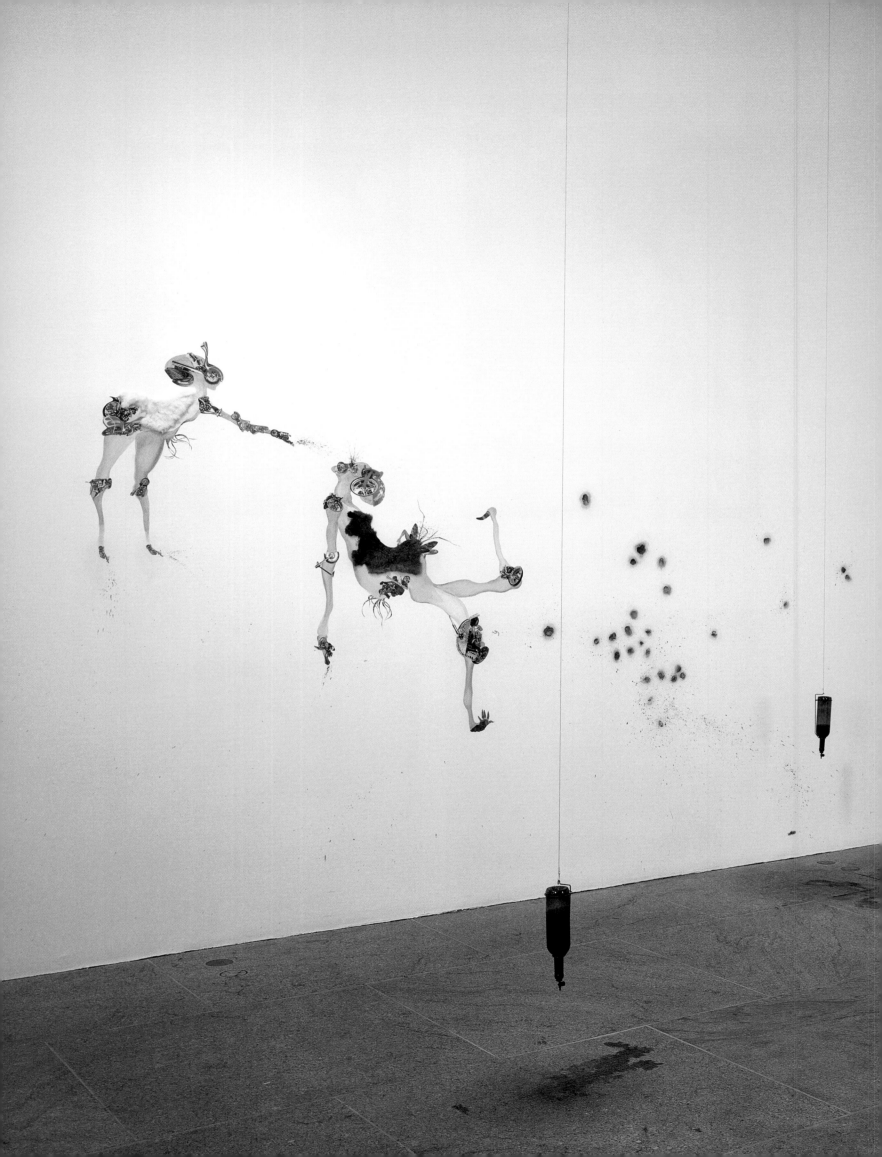

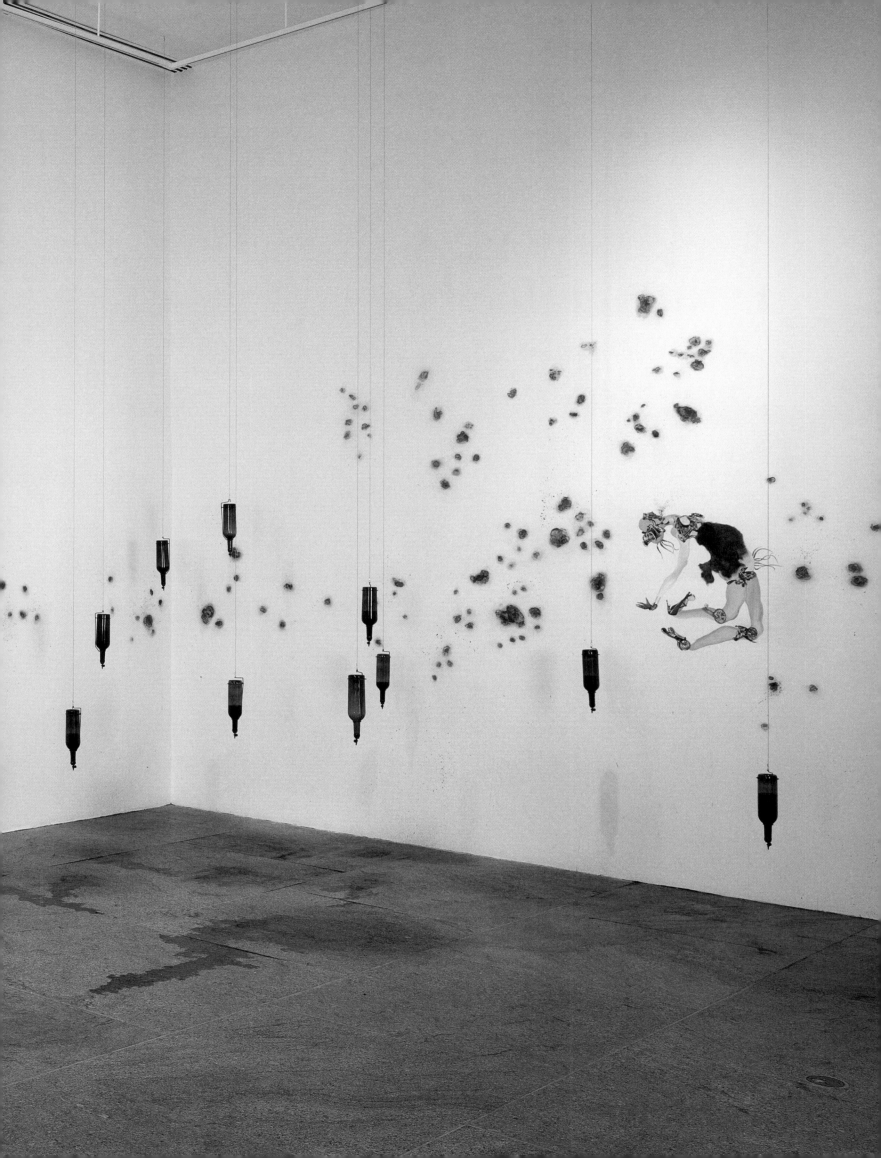

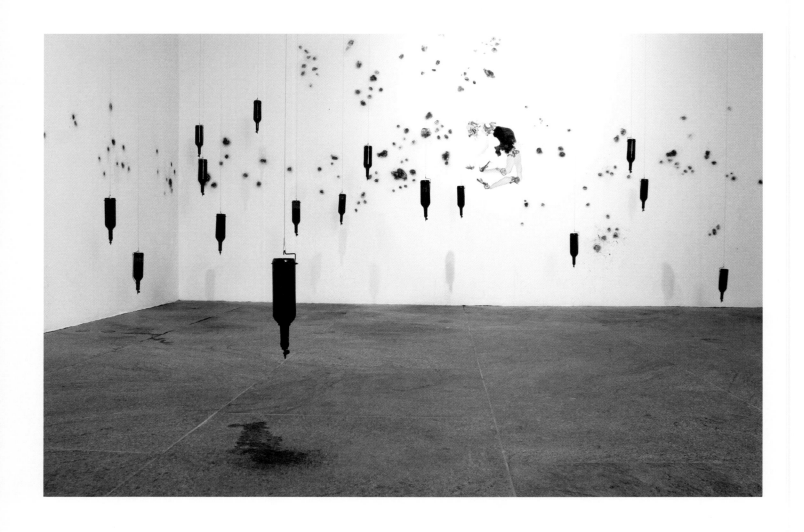

A Shady Promise

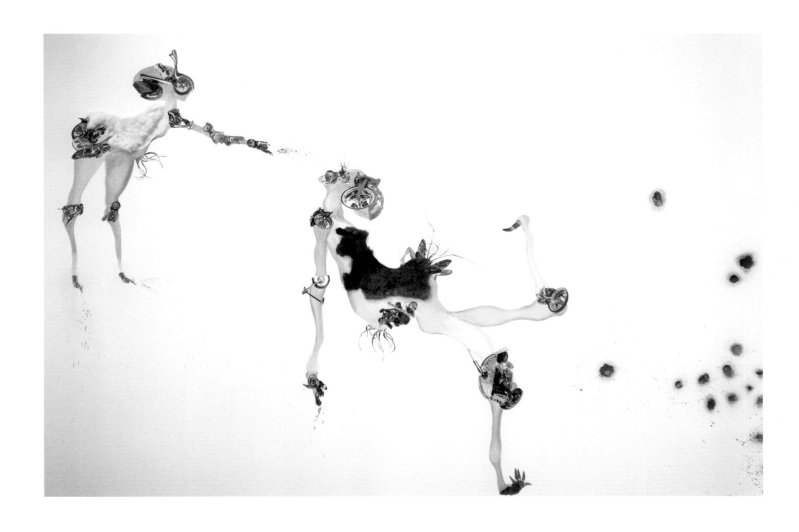

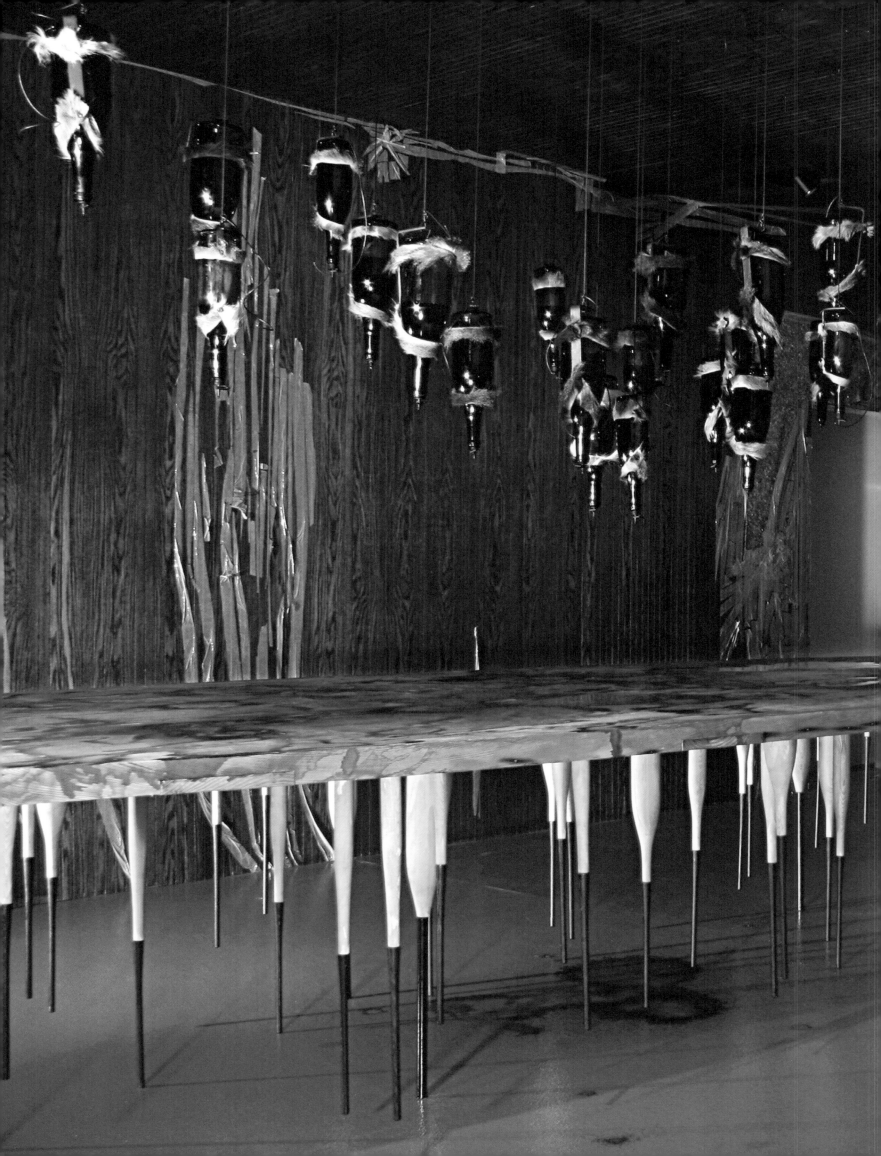

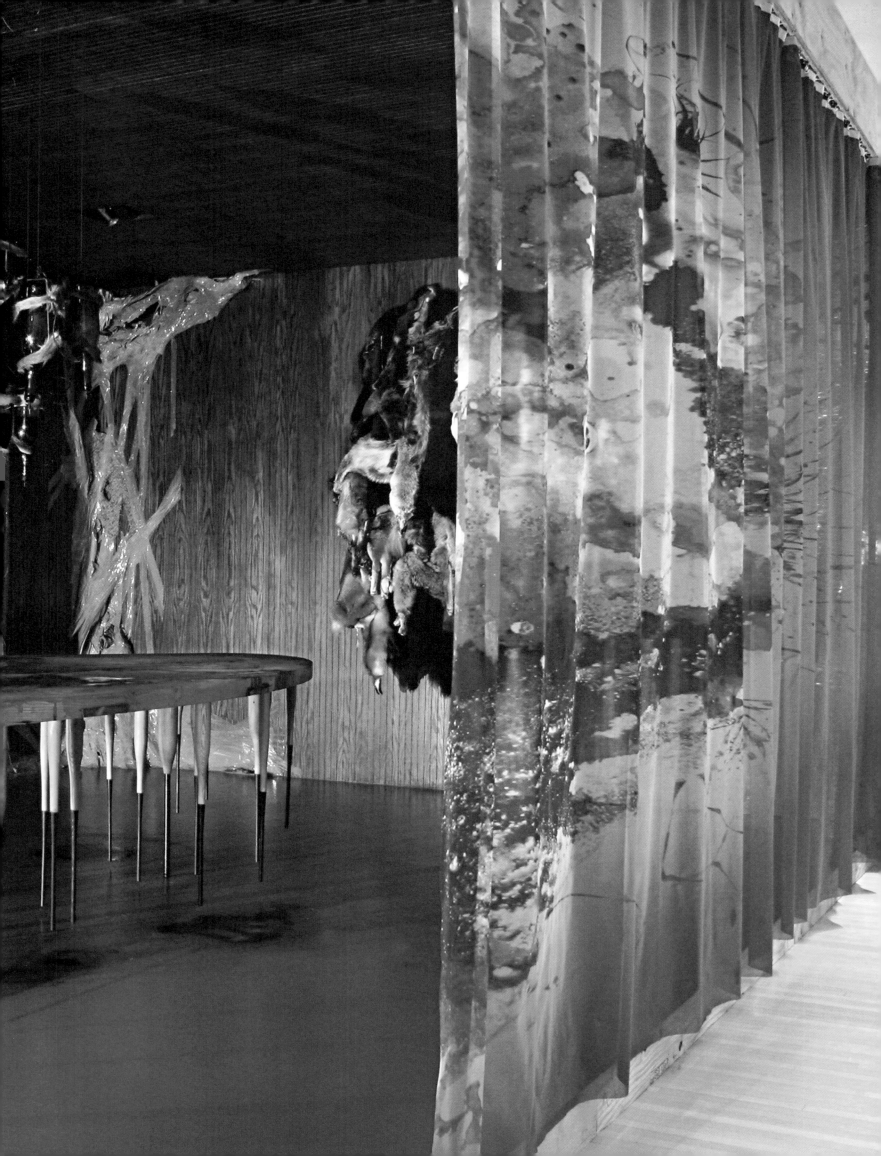

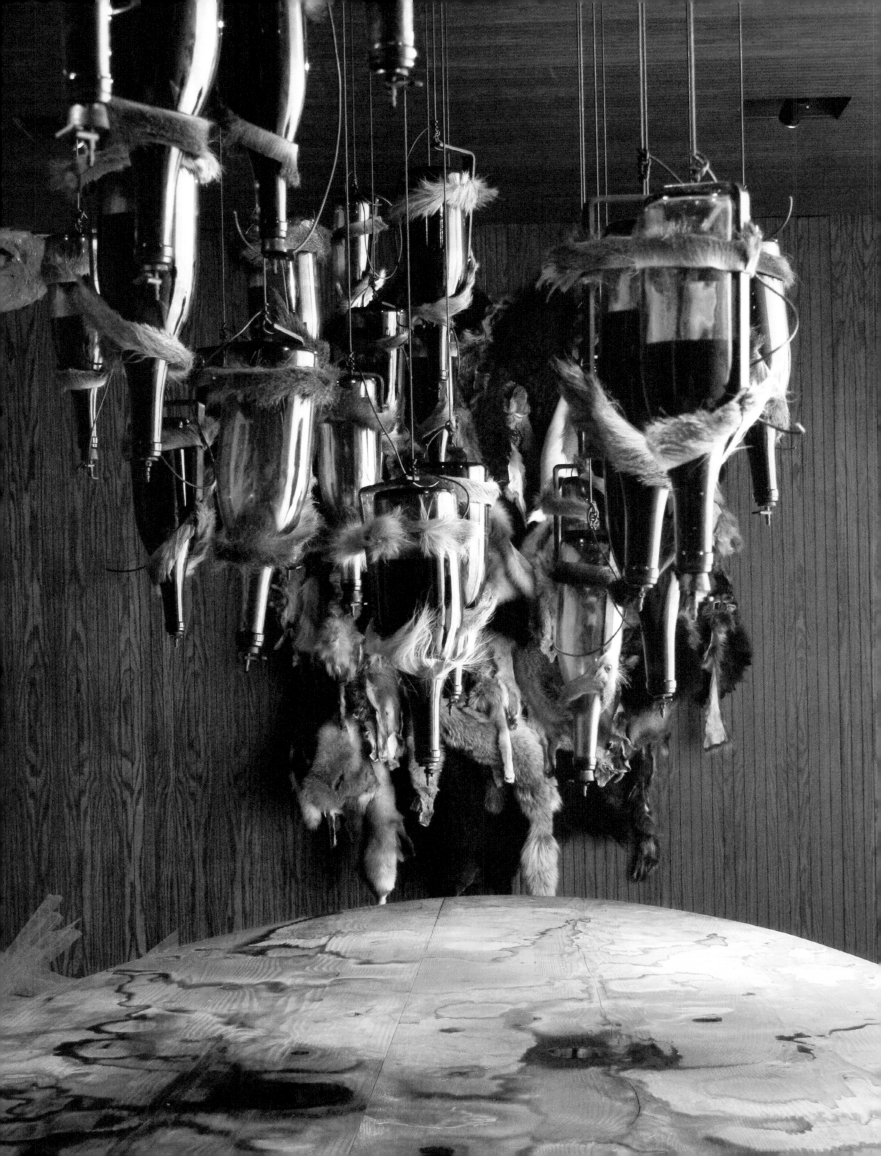

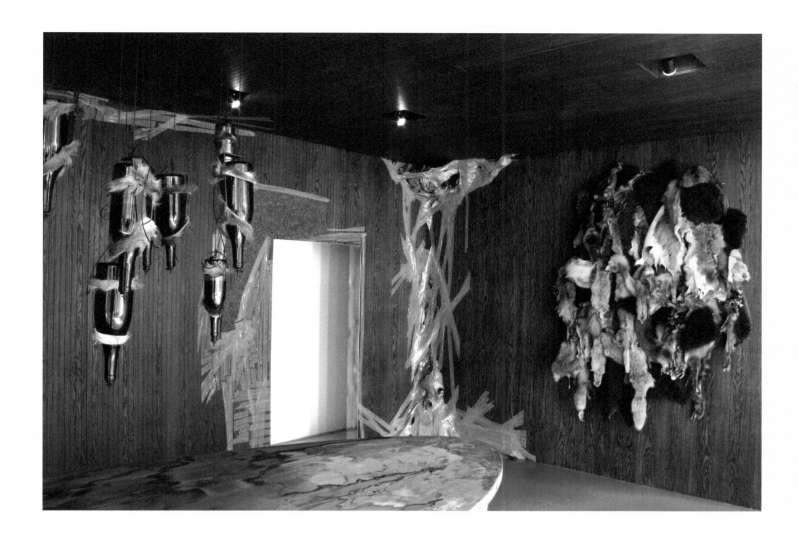

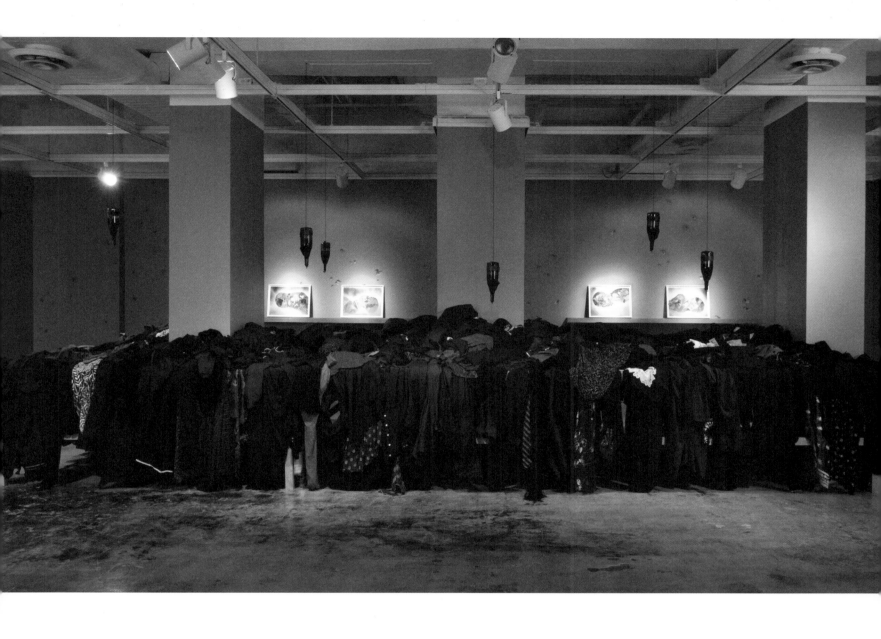

The Cinderella Curse, 2007, Dimensions Variable, Savannah College of Art and Design

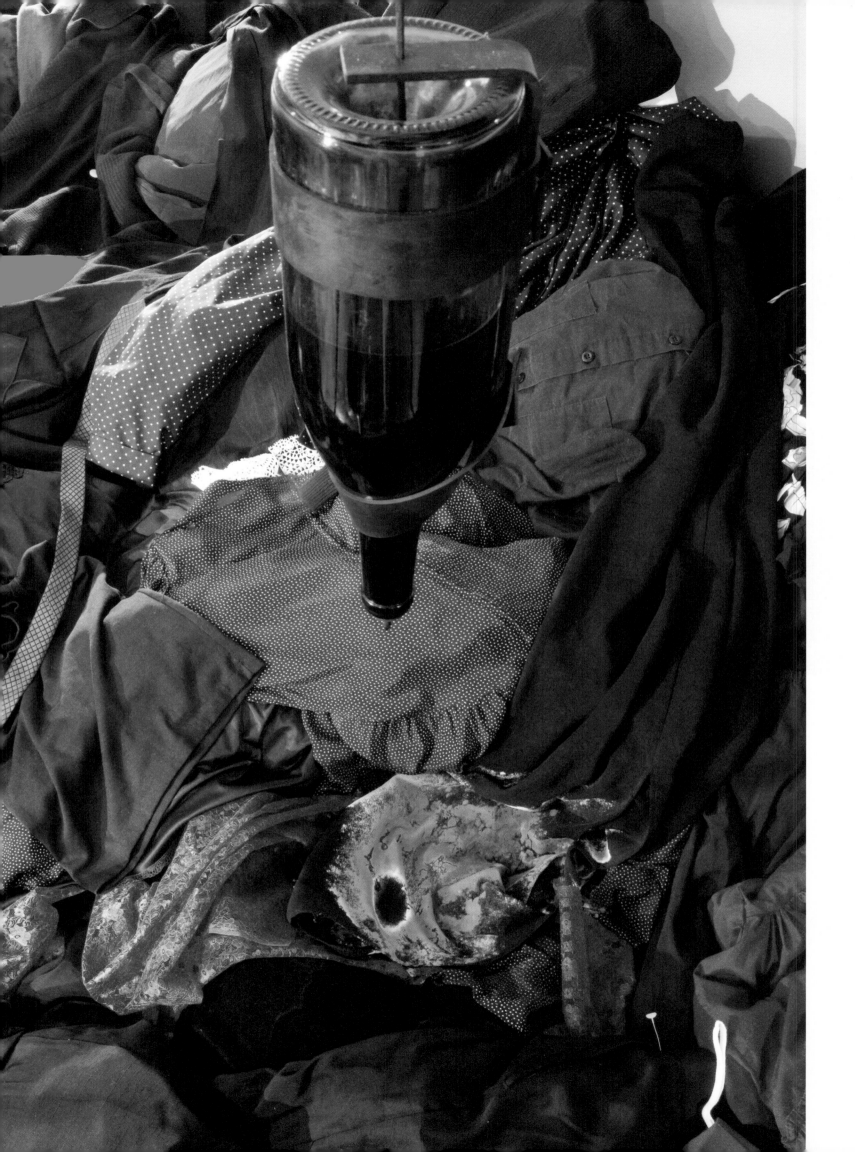

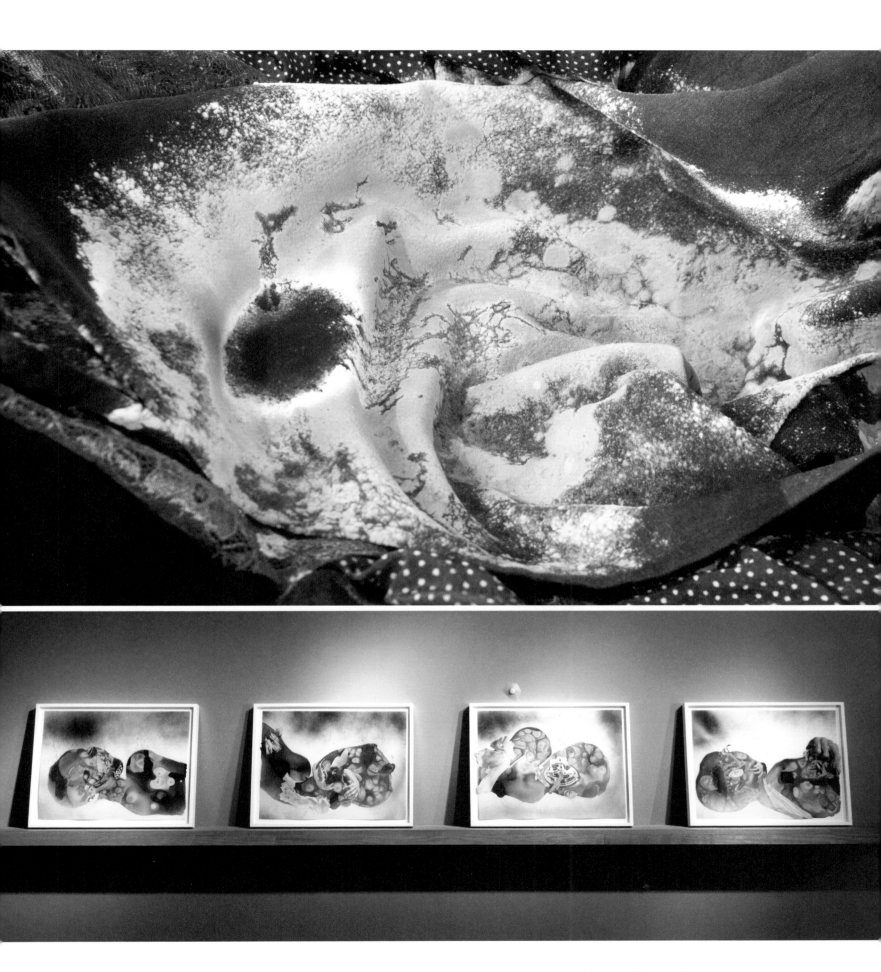

LEFT, TOP, ABOVE: *The Cinderella Curse*, 2007, Dimensions Variable, Savannah College of Art and Design

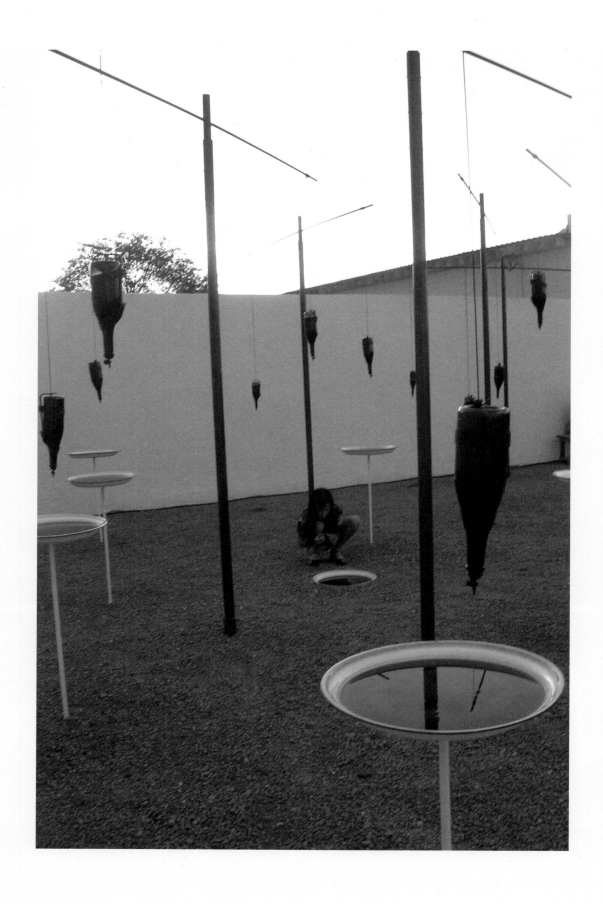

The Masters Imaginary Dual is Over, 2006, Dimensions Variable, Ballroom Marfa

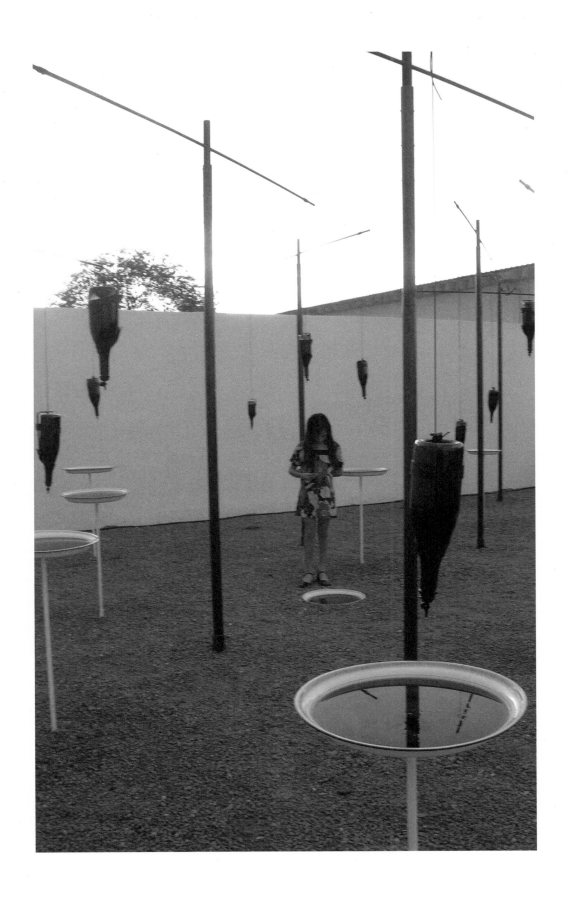

The Masters Imaginary Dual is Over, 2006, Dimensions Variable, Ballroom Marfa

A Shady Promise

CHAPTER FOUR

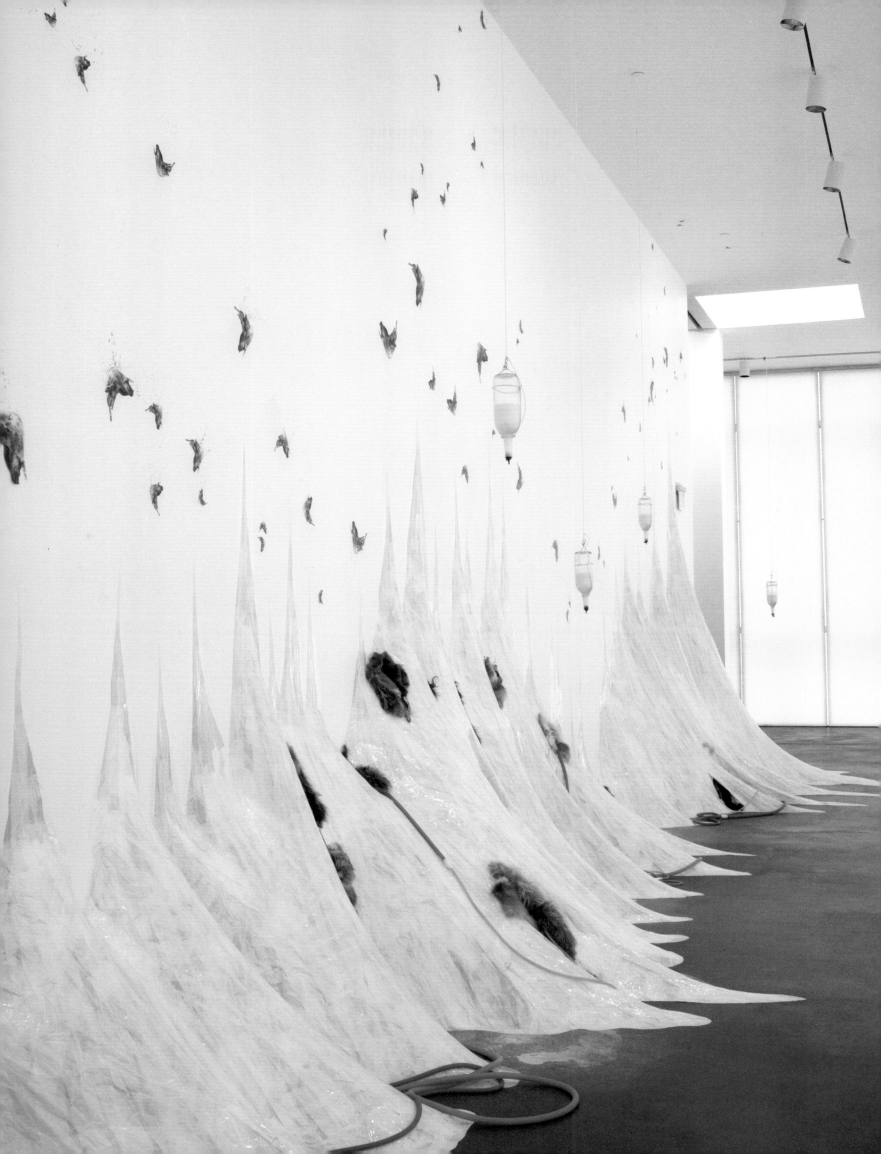

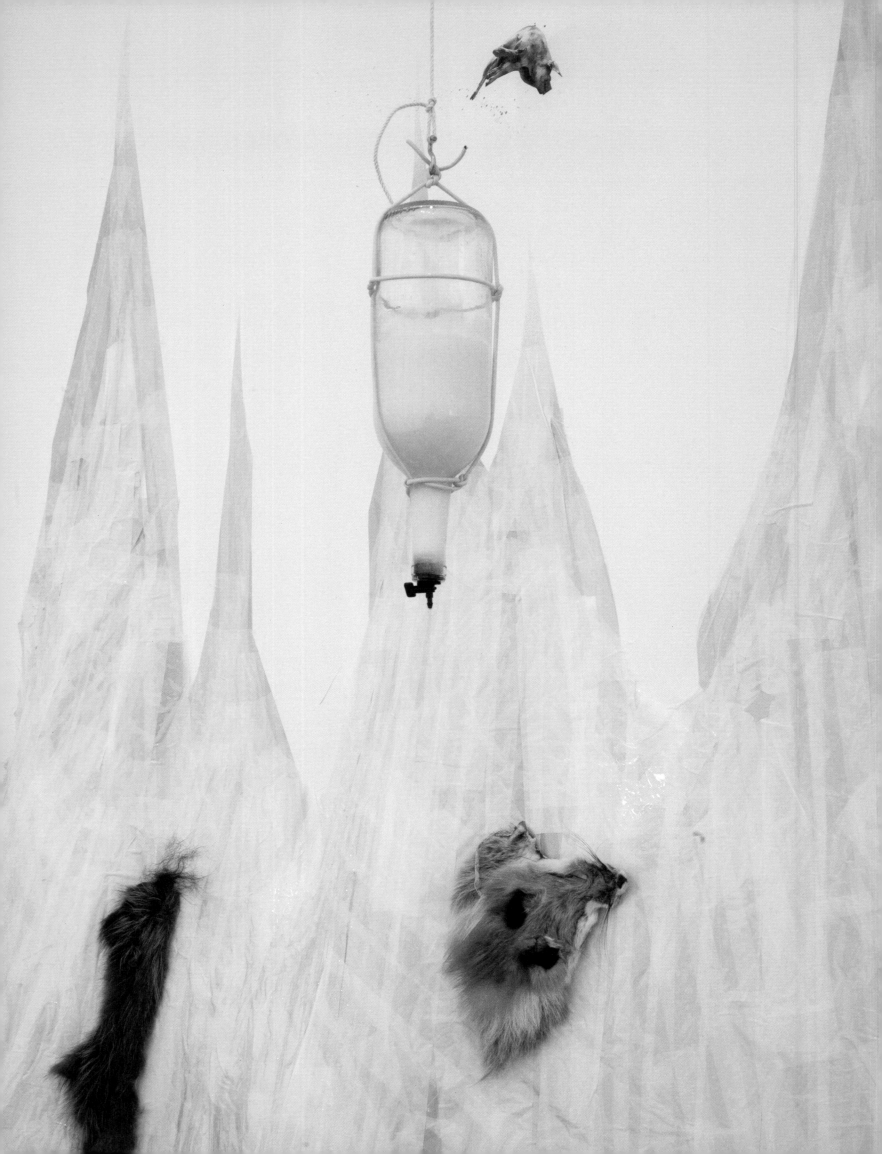

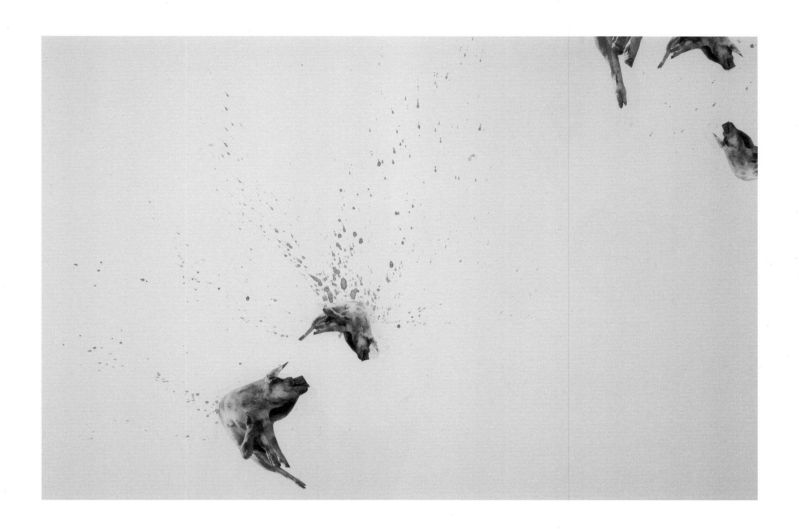

PREVIOUS SPREAD, LEFT, TOP, ABOVE: *Will Honey Flavoured Milk Soften That Pig Fed Rage?*, 2007, Dimensions Variable, Museum of Contemporary Art Denver

A Shady Promise

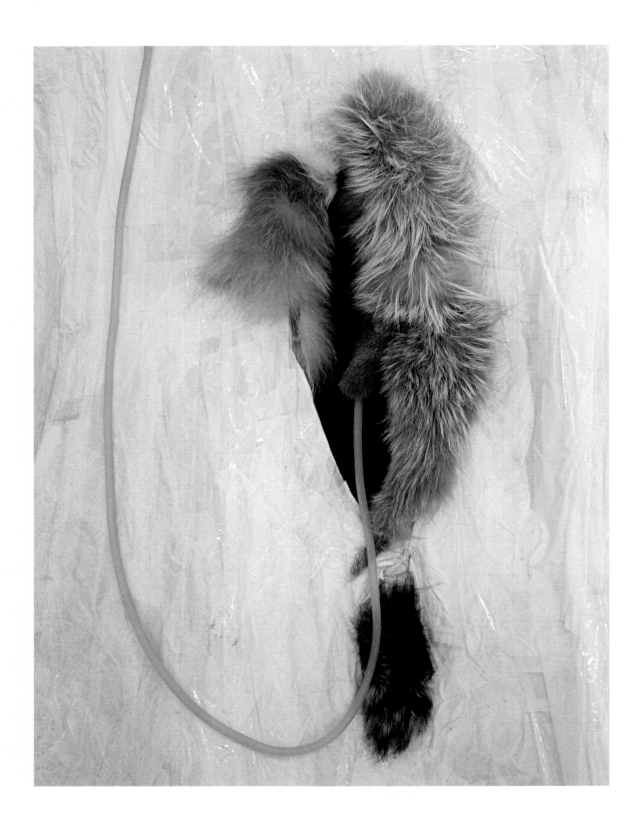

Detail, *Will Honey Flavoured Milk Soften That Pig Fed Rage?*, 2007, Installation, milk bottles, tape, fur, shoes, ink and mixed media

TACTICAL COLLAGE

Malik Gaines & Alexandro Segade

Wangechi Mutu uses collage as a tactic. Even the works that aren't strict collage convey the technique's call for juxtaposition and displacement. A New York artist from Kenya who was educated both in Africa and the States and is working in an expanded art market across national borders, Mutu herself narrates a contemporary global experience, just as the bodies she invents challenge the comfort with which we receive such narratives. Medium specificity is not very important these days, at least not in critical circles (which are also not so important); in Mutu's case, collage suggests not only a crafty art medium but also a way of organizing the possibilities of one's life.

All the same, hand-made marks figure boldly across Mutu's figures. Her drawings are vigorous compositions of surreal violence. Loose, familiar scrawls depict women who appear as icons, folk imagery that serves as a reminder of origin myths and end plans. The women's sex organs are likened to open wounds, or disembodied knots in trees. Violence to these female bodies is both ecstatic and horrible, as present events intervene with an ever-fascinating castration fantasy. The violence is a reality, despite the dreamlike quality of its representation. History marks bodies. The artist responds in sketches that are diaristic, masturbatory, and masochistic notes on embodiment.

Mutu's series of the *Pin-Up* are works on paper that display the female body as a site of depiction. The flesh of the figures, long limbed with big behinds, is painted in brown, tan and gold watercolors. The features and hair are cut out from fashion magazines in arbitrary shapes that do not conform to the corresponding eyes or lips they replace, revealing the pale skin of the original source, tacked onto Mutu's paintings with an aggressive awkwardness. Mutu evokes a particular art history; cultural assumptions about race and beauty have been expressed and explored in works such as those by Lorna Simpson, in which these mechanisms are explained as if they could be understood. Martha Rosler's memorable collage of Playboy centerfolds offers both pleasure and a critique in its utopian world of women born from the trash of heterosexual male porn. One is reminded of the Situationist strategy of détournement in which images from advertising were to be re-scripted and used for political agitation. Distrustful of art making and other forms of visual production, Guy Debord employed stock and news footage, as well as scenes from old movies, in his film version of *The Society of the Spectacle*. But what stands out most in that film are all the soft-core boobs that play against his description of Spectacular time. Mass culture makes the female body into a banality, a threatening negation for the people who live in such bodies. In Mutu's body of work, this condition reveals itself not as a coherent system of oppression, but as a disjointed mode of being.

The concern here is not simply for the female body, which elides so easily into a neutral code of universal object, but the black female body, a body doubly marked. In the *Ark Collection*, Mutu places images of black models from porn magazines over postcards from Africa, often in clever compositions that create a trompe l'oeils effect: in a hole in the paper where a pouting mouth should be, there is a feather from the layer beneath, attached to skin of a different shade. The artist skillfully contrasts *National Geographic*-style depictions with hip-hop inflected porn, showing the ways in which looking, for educational or prurient purposes, makes spectacles of flesh that are both incomplete and over-determined. These works suggest a wry pleasure in taking fake identities apart. Far from the trepidation suggested by Susan Sontag's call for an ecology of images, Mutu recycles from the Image World's onslaught, making striking forms out of fractured pictures of emptied-out desire.

Wangechi Mutu's great creations—created in a vein similar to that with which Mary Shelley's Frankenstein constructed his monster, from a variety of abject sources—are her hybrids. At once both alien and earthy, these dancing goddesses are trans-species pin-ups of a different sort. Their painted body parts dispense with skin-tones in favor of violets, blues, oranges and greens set among rich soil-colors, dripping, splotchy and moist. This is chameleon-like skin: no longer standardized by race, the women seem fungal, or floral, or animal. And then, every so often, they wear fancy, high-heeled shoes, or possess a knee made from a metal wheel. Like Donna J. Haraway's cyborgs, Mutu's hybrids are females who do not fear technology, because they are made of it.

One is reminded of Octavia E. Butler's sci-fi vision. In the novelist's Xenogenesis trilogy, a sophisticated alien race cruises the universe searching for its future. In the first book, *Dawn*, a tall, strong black woman named Lilith is the protagonist who must face the radical possibility of mating with tentacled aliens who are described in a way that suggests Mutu's own slithery spawn. Lilith discovers that she's been selected as original mother to the new hybrid beings. At first she's freaked out, but eventually she accepts her destiny because, as we all know, *Space is the Place*. As in much of her writing, Butler shows us that though the future is scary and bizarre, a black woman can nonetheless take us there without fear. First she must accept hybridity, dehumanizing technology, and otherworldly love. Like Butler's speculative fiction, Mutu's hybrids illustrate marks on the subject left by processes described in post-colonial theory. *Riding Death in My Sleep* shows a bald woman attended by flying lizards crouching intently on a living heap of mushrooms, bringing to mind what Frantz Fanon called "a zone of occult instability," that condition of living in a lifeworld of multiple discourses and cultural differentiations. In Mutu's hybrids, we find totems of power formed strategically from broken-off pieces of culture. Their expressions are neither defiant nor defeated, but rather, mysteriously ambivalent.

The construction of race continues to be performed in ever-mutating cultural forms, as the construction of the human race too faces a new kind of entropy. Human-animal hybrids, called Chimera by geneticists in reference to the classical beastie made of a goat, snake, and lioness, exist in mice with human brain cells that are used to study Alzheimer's. In his 2006 State of the Union address George Bush declared a ban on such inventions, citing the importance of maintaining strict taxonomical order. In the hybrids of Wangechi Mutu, the human and animal are collaged as a tactic for defying the tyrannical, taxonomical order of seeing, that most violent imposition onto the bodies of those made into specimen.

Mutu continues her exploration of the body through installation, evoking the commercial window dressing that shapes desire and identity in our acquisition-happy society. But none of these projects offer a reliable body for consumption. There are no unified subjects in the works of Wangechi Mutu. Her images are gorgeous and scary, and feel particularly apt at describing what it's like to be present now. It takes some doing to find something interesting to say to art viewers through the tradition of the female nude, and Mutu has done it.

COLLAGE STRATEGICO

Malik Gaines e Alexandro Segade

Wangechi Mutu utilizza il collage come strategia. Anche i lavori che non sono precisamente collage veicolano il richiamo di questa tecnica alla giustapposizione e alla dislocazione. Artista newyorkese di origine keniota, con formazione in parte africana e in parte statunitense, che agisce in un mercato dell'arte esteso oltre le barriere nazionali, Mutu stessa racconta un'esperienza contemporanea globale proprio nel momento in cui i corpi che inventa sfidano la comodità con cui riceviamo tali narrazioni. Oggi la specificità del mezzo non è di grande rilievo, quantomeno non negli ambienti più critici (anch'essi per la verità non così importanti); nel caso di Mutu, il collage non propone solo un efficace mezzo artistico, ma anche una modalità per strutturare le possibilità della propria vita.

Contemporaneamente, le impronte artigianali si stagliano sfrontatamente in tutte le figure di Mutu. I suoi disegni costituiscono vigorose composizioni di violenza surreale. Scarabocchi informali e approssimativi ritraggono donne che appaiono come icone, come simboli popolari che fungono da richiamo a miti d'origine e a idee di rovina. Gli organi sessuali delle sue donne sono assimilati a ferite aperte, o ai nodi disincarnati di un albero. La violenza esercitata su questi corpi femminili è ad un tempo estatica e atroce, mentre gli eventi presenti intervengono con una fantasia di castrazione che non perde mai il suo potere di seduzione. Pur nella natura fantastica della sua rappresentazione, la violenza è realtà. La storia marchia i corpi. L'artista risponde con schizzi che sono annotazioni diaristiche, masturbatorie e masochistiche sull'*embodiment*.

Le *Pin-Up* di Mutu sono una serie di opere su carta che mettono in mostra il corpo femminile come luogo di rappresentazione. I loro corpi, dalle lunghe membra e dai sederi voluminosi, sono colorati con acquerelli in tonalità dorate e più o meno scure di marrone. I lineamenti e i capelli sono ritagliati da riviste di moda in forme casuali che non corrispondono agli occhi o alle labbra che sostituiscono, lasciando intravedere la pelle chiara della fonte originale, appiccicata sui dipinti di Mutu con goffaggine aggressiva. Mutu evoca una storia dell'arte specifica; gli assunti culturali in merito alla razza e alla bellezza sono stati enunciati e indagati all'interno di lavori come quelli di Lorna Simpson, in cui tali meccanismi vengono illustrati come se potessero essere compresi. L'indimenticabile collage costruito da Martha Rosler sulle pagine centrali di Playboy consente sia un apprezzamento che una critica a quel mondo utopico fatto di donne nate dal porno trash del maschio eterosessuale. Si sente un richiamo alla strategia situazionista del *détournement*, in cui le sceneggiature delle immagini pubblicitarie venivano riscritte ed utilizzate a scopi di agitazione politica. Diffidando dell'arte e di altre forme di produzione visiva, Guy Debord utilizzò spezzoni di notiziari e scene di vecchie pellicole nella sua versione filmica de *La società dello spettacolo*. Ma quello che nel film emerge maggiormente sono quelle immagini soft-core di tette che giocano contro la sua descrizione del tempo spettacolare. La cultura di massa traduce il corpo femminile in una banalità, in un'insidiosa negazione degli individui che quei corpi abitano. Nel corpus artistico di Mutu, tale condizione non si rivela come un sistema coerente di oppressione, ma come modalità disgregata di esistenza.

L'interesse, in questo caso, non si concentra semplicemente sul corpo femminile che con facilità si annulla nel codice neutro di oggetto universale, ma sul corpo femminile nero, un corpo doppiamente marchiato. In *Ark Collection*, Mutu colloca immagini di modelle nere tratte da riviste porno su cartoline dell'Africa, creando ingegnose composizioni che producono un effetto di trompe l'oeil: una fessura nella carta in cui dovrebbe stare una bocca imbronciata ospita invece una piuma dello strato sottostante, unita ad una pelle di tonalità diversa. L'artista mette abilmente a confronto le rappre-

sentazioni stile *National Geographic* e il porno modulato dalla cultura hip-hop, svelando le modalità secondo cui il guardare, con intento didattico o lascivo, restituisca immagini del corpo che sono ad un tempo incomplete ed eccessivamente definite. Questi lavori suggeriscono la presenza di un godimento cinico nell'atto stesso dello smantellamento di identità fittizie. Lontana dall'ansia veicolata dall'invocazione di Susan Sontag ad un'ecologia delle immagini, Mutu ricicla attingendo alla profusione del Mondo dell'Immagine e dà vita a figure sorprendenti, partendo dalle immagini spezzate di un desiderio inaridito.

Le grandi creazioni di Wangechi Mutu, realizzate con una disposizione analoga a quella con cui il Frankenstein di Mary Shelley crea il suo mostro da una varietà di fonti abiette, sono i suoi ibridi. Ad un tempo aliene e terrene, queste dee danzanti sono pin-up transpecie di un genere altro. Le parti dipinte del loro corpo si liberano delle tonalità della pelle per lasciare spazio ai viola, blu, arancio e verde incastonati tra i ricchi colori della terra sgocciolanti, macchiati e umidi. È la pelle camaleontica: non più tipizzate dalla razza, queste donne appaiono come creature fungine, floreali o animali. Ogni tanto, poi, indossano bizzarre scarpe coi tacchi o mostrano un ginocchio fatto di una ruota metallica. Come i cyborg di Donna J. Haraway, gli ibridi di Mutu sono donne che non temono la tecnologia, perchè di tecnologia sono fatte.

Si avverte un richiamo alla visione fantascientifica di Octavia E. Butler. Nella sua trilogia della xenogenesi, una raffinata razza aliena attraversa l'universo in cerca del proprio futuro. Nel primo libro, *Dawn*, la protagonista è un'alta e possente donna nera di nome Lilith, che deve affrontare la rivoluzionaria possibilità di unirsi con degli alieni tentacolati, descritti in un modo che rimanda all'ambigua progenie di Mutu. Lilith scopre di essere stata scelta come genitrice originaria dei nuovi esseri ibridi. Inizialmente rimane scioccata, ma poi accetta il suo destino perché, come tutti noi sappiamo, *Space is the Place*. Come in molta della sua produzione, Butler ci mostra come, benché il futuro sia terrificante e bizzarro, una donna nera possa condurci senza paura alla sua scoperta. Deve innanzitutto accettare l'ibridità, disumanizzando la tecnologia, e l'amore oltre i confini del terreno. Come la narrativa speculativa di Butler, gli ibridi di Mutu svelano i segni lasciati sul soggetto dai processi descritti dalla teoria post-coloniale. *Riding Death in My Sleep* mostra una donna senza capelli attorniata da lucertole volanti che si china assorta su un mucchio di funghi viventi, riportando alla mente quella che Frantz Fanon chiamava "una zona di instabilità occulta", la condizione di esistenza in un "mondo della vita" costituito da discorsi molteplici e da differenziazioni culturali. Negli ibridi di Mutu ritroviamo totem del potere costruiti strategicamente a partire da pezzi frammentati di cultura. Le loro espressioni non sono né provocatorie né arrendevoli ma, piuttosto, misteriosamente ambivalenti.

La costruzione della razza continua ad essere praticata secondo forme culturali in costante trasformazione, allo stesso modo in cui la costruzione dell'umanità affronta una nuova fase di entropia. Gli ibridi umano-animali che i genetisti chiamano chimera con riferimento alla fiera classica, in parte caprone, in parte serpente e in parte leonessa, vivono nei topi impiantati di cellule cerebrali umane e utilizzati per studiare l'Alzheimer. Nel suo State of the Union address del 2006, George Bush ha messo al bando tali invenzioni, appellandosi all'importanza di mantenere un rigido ordine tassonomico. Negli ibridi di Wangechi Mutu, l'umano e l'animale sono uniti in collage come strategia di resistenza verso l'ordine visivo tirannico e classificatorio, verso l'imposizione oltremodo violenta esercitata sui corpi da coloro che sono stati eletti a modello.

Mutu continua l'indagine sul corpo attraverso la tecnica dell'installazione, evocando l'allestimento della vetrina commerciale che nella nostra società dell'acquisto forgia desiderio e identità. Nessuno di questi progetti offre però un corpo di consumo affidabile. Non esistono soggetti uniformi nei lavori di Wangechi Mutu. Le sue immagini sono splendide e spaventose e si rendono particolarmente adatte a descrivere che cosa significhi esistere ora. È faticoso trovare qualcosa di interessante da comunicare allo spettatore passando attraverso la tradizione del nudo femminile, ma Mutu ci è riuscita.

WANGECHI MUTU
Lives and works in New York

SOLO EXHIBITIONS

2007
The Cinderella Curse, ACA Gallery of SCAD,
Atlanta, GA
Cleaning Earth, Franklin Artworks,
Minneapolis, MN

2006
An Alien Eye and Other Killah Anthems,
Sikkema Jenkins Co., New York, NY
Exhuming Gluttony: A Lover's Requiem,
Salon 94, New York, NY
Sleeping Heads Lie, Power House,
Memphis, TN

2005
The Chief Lair's A Holy Mess, San
Francisco Museum of Modern Art,
San Francisco, CA
Wangechi Mutu — Amazing Grace, Miami
Art Museum, Miami, FL
Problematica, Susanne Vielmetter Los
Angeles Projects, Los Angeles, CA

2004
Hangin In Texas, Art Pace,
San Antonio, TX

2003
Pagan Poetry, Susanne Vielmetter Los
Angeles Projects, Los Angeles, CA

2002
Creatures, Jamaica Center for the Arts and
Learning, Queens, NY

1999
Surely It Can't Burn So Long, Rush Arts
Gallery, New York, NY

GROUP EXHIBITIONS

2008
Collage: The Unmonumental Picture, The
New Museum, New York, NY

2007
Star Power: Museum As Body Electric,
Museum of Contemporary Art Denver,
curated by Cydney Payton, Denver, CO
Every Revolution is a Roll of the Dice,
Ballroom Marfa, curated by Bob Nickas,
Marfa, TX
Fractured Figure, curated by Jeffrey
Deitch, Athens, Greece
*global feminisms: New Directions in
Contemporary Art*, Brooklyn Museum,
curated by Maura Reilly, Brooklyn, NY

2006
(Re)Volver, Plataforma Revolver, curated by
Filipa Oliveira, Lisboa, Portugal

New York Interrupted, PMK Gallery, cur-
ated by Dan Cameron, Beijing, China
USA TODAY, Royal Academy of the Arts,
London, UK
2nd Biennial Contemporary Art in Seville,
Centro Andaluz de Arte Contempora-
neo, curated by Okwui Enwezor, Sevilla,
Spain
Interstellar Low Ways — Sun Ra, Hyde Park
Art Center, curated by Huey Copeland,
Chicago, IL
Distant Relatives/Relative Distance, The
Michael Stevenson Gallery, Cape Town,
South Africa
Land Mine, The Aldrich Museum,
Ridgefield, CT
*Still Points in the Turning World: SITE Santa
Fe's Sixth Annual Biennial*, curated by
Klaus Ottman, Santa Fe, NM
*Infinite Painting — Contemporary Painting
and Global Realism*, Villa Manin
Centre for Contemporary Art, curated
by Francesco Bonami and Sarah
Cosulich Canarutto, Passariano, Italy
The F-Word: Female Vocals, Warhol Mu-
seum, Pittsburgh, PA
Out of Time: A Contemporary View,
Museum of Modern Art, curator
Joachhim Pissarro, Department of
Painting and Sculpture, New York, NY

2005
After Cezanne, The Museum of
Contemporary Art, LA, Los Angeles, CA
*Matisse and Beyond — The Painting
and Sculpture Collections*,
San Francisco Museum of Modern Art,
San Francisco, CA
Cut, Susanne Vielmetter Los Angeles
Projects, Culver City, CA
Drawing from The Modern, 1975-2005,
curated by Jordan Kantor, Museum of
Modern Art, New York, NY
Greater New York 2005, PS1, Long Island
City, NY
Follow Me: A Fantasy, Arena 1, curated by
Malik Gaines, Santa Monica, CA
Rewind/Re-Cast/Review, Berrie Arts Center,
Ramapo College Galleries, curated by
Isolde Brielmaier, NJ
*Only Skin Deep: Changing Visions of the
American Self*, International Center of
Photography, curated by Brian Wallis
and Coco Fusco, New York, NY

2004
Pin-Up: Contemporary Collage and Drawing,
Tate Modern, London, UK
Fight or Flight, Whitney Museum of
American Art at Altria, New York, NY
Gwangju Biennial, South Korea
Color Theory, Vitamin Arte
Contemporanea, curated by Franklin
Sirmans, Torino, Italy

Africa Remix, Kunstpalast Duesseldorf,
Germany
Color Wheel Oblivion, Marella Arte
Contemporanea, curated by Chris
Perez, Milan, Italy

2003
*Looking Both Ways: Art of the Contemporary
African Diaspora*, Museum for African
Art, curated by Laurie Ann Farrell,
Long Island City, NY
We Are Electric, Deitch Projects, curated
by Chris Perez, New York, NY
New Art Wave, Brooklyn Academy
of Music, curator Dan Cameron,
Brooklyn, NY
Off the Record, Skylight Gallery, curated by
Kambui Olujimi, Brooklyn, NY
Open House: Working in Brooklyn, Brooklyn
Museum of Art, Brooklyn, NY
*Black President: The Art and Legacy of
Fela Anikulapo-Kuti*, curated by Trevor
Schoonmaker, The New Museum,
New York, NY

2002
Scratch, Arena Gallery, New York, NY
Brooklyn in Paris, Gallery Chez Valentin,
Paris, France
Model Citizens, Roger Smith Gallery,
curated by Janet Dees, New York, NY
Culture In A Jar, Longwood Arts Project,
curated by Wanda Ortiz, New York, NY
Africaine, The Studio Museum in Harlem,
curated by Christine Kim, New York, NY

2001
Fusion, MoCada, New York, NY
Out of the Box, Queens Museum,
New York, NY
Group Show, River Bank Gallery,
New York, NY

2000
The Magic City, curated by Trevor
Schoonmaker, Brent Sikkema,
New York, NY

1997
Life's Little Necessities, Johannesburg
Biennale, The Castle, curated by Kellie
Jones, Cape Town, South Africa

biting "the" hand ca feed you.

A Shady Promise

BIBLIOGRAPHY

2008

Flood, Richard, Hoptman, Laura, and Gioni, Massimiliano, *Collage: The Unmonumental Picture*, New Museum with Merrill Publishers/Mondadori Electa, 2008.

2007

Eshun, Ekow. "The Art of Darkness", *Vogue*, November 2007, pp. 131-132.

"Every Revolution is a Roll of the Dice", *The Big Bend Sentinel*, The Arts section, September 20, 2007, p. 7.

Mullins, Charlotte. *Painting People: Figure Painting Today*, 2007, p. 110.

Aldarondo, Cecilia. "Ghada Amer + Wangechi Mutu: Minneapolis", *Art Papers*, May/June 2007, p. 66.

Kruger, Barbara. "WANGECHI MUTU", portrait by Albert Watson, *Interview*, April 2007, p. 119.

Nolan, Joe. "Wangechi Mutu: Sleeping Heads Lie", *Number: No 58*, Spring 2007.

Koenig, Wendy. "Wangechi Mutu: Memphis", *Art Papers*, March/April 2007, p. 62.

Abbie, Mary. "Feminism Revisited: Art By Two African-Born Women Revitalizes Feminist Issues In A Handsome Franklin Art Show" *Star Tribune*, Art Section, March 2007, p. F16.

Reilly, Maura, and Nochlin, Linda, eds. *Global Feminisms: New Directions in Contemporary Art*, 2007, p. 53.

Cotter, Holland. "Feminist Art Finally Takes Center Stage", *The New York Times*, January 29, 2007, Section E, p. 1.

2006

Korotkin, Lindsay. "Reviews", *Tema Celeste*, Nov/Dec 2006, p. 78.

Martin, Courtney. "Site Santa Fe: 6th International Biennial, Still Points of the Turning World", *Contemporary*, Issue No. 86, 2006, p. 64.

Carver, Jon. "Still Points of the Turning World", *Art Papers*, Nov/Dec 2006, p. 69.

Murinik, Tracy. "Afro-Alien Exquisite Corpses", *Art South Africa*, Spring 2006, pp. 26-29.

Klopper, Sandra. "Distant Relatives / Relative Distance," *Art South Africa*, Spring 2006, pp. 64-65.

Murray, D.C. "Wangechi Mutu at SFMoMA", *Art in America*, October 2006, p. 205.

Colpitt, Frances. "A Slow-Motion Biennial", *Art in America*, October 2006, pp. 69-75.

Auricchio, Laura. "Wangechi Mutu", *Art Papers*, Sept/Oct 2006.

Kazanjian, Dodie. "Fierce Creatures", *Vogue*, June 2006.

Maart, Brenton. "Distant Relatives: Artists of the African Diaspora", *Mail and Guardian*, Western Cape South Africa, Nov. 3-9, 2006, Vol. 22, #43, p.2.

Smith, Roberta. "Wangechi Mutu: An Alien Eye and Other Killah Anthems", *The New York Times*, June 9, 2006.

Helfand, Glen. "Voluptuous Horror", *The San Francisco Bay Guardian*, January 4-10, 2006, vol. 40, no. 14.

2005

Kantor, Jordan. *Vitamin D: New Perspectives in Drawings*, Phaidon Press, London and New York, 2005, essay p. 214, illustrations pp. 215-217, bio p. 334.

Oliveira, Filipa. "Wangechi Mutu", *W-Art Contemporary Art Magazine*, Issue no. 008, pp. 66-69.

Brielmaier, Isolde. "Wangechi Mutu: Re-imagining the World", *Parkett 74*, 2005.

Hatcher, David. "Poco a Go-Go: Wangechi Mutu at Susanne Vielmetter LA Projects", *X-TRA Contemporary Arts Quarterly*, Vol. 8, Issue 1.

Kantor, Jordan. *Drawing from The Modern: 1975-2005*, Museum of Modern Art, New York, p. 185.

Pollack, Barbara. "Panic Room", *Time Out New York*, January 13-19 2005, pp. 55-56.

Korotkin, Joyce B. "Fight or Flight", *Tema Celeste*, May-June 2005, pp. 76-77.

Heartney, Eleanor. "Return to the Real", *Art in America*, June/July issue, pp. 85-89.

Chevalier, Jari. "Greater New York Show at P.S.1", *The New York Art World.com*, April 2005.

Andersson, Ruben. "Mixed Bag of African Avant-Garde", *The London Globe*, March 20, 2005.

"Color Wheel Oblivion", *Marella Arte Contemporanea*, pp. 38-40.

"Future Greats 2005", *Art Review*, Volume IX, December 2005, p. 99.

Harrison, Sara. "Pin-Up: Contemporary Collage and Drawing", *Art Monthly*, February 2005.

Brownell, Ginanne. "Front and Center: In London, It's The Year Of African Art", *Newsweek*, February 17, 2005.

2004

Kerr, Merrily. "Extreme Makeovers", *Art on Paper*, July/August 2004, pp. 28-9.

Leitzes, Cary Estes. "Body Politic", *ArtReview*, September 2004.

Ciuraru, Carmela. "Cutting Remarks", *ArtNews*, November 2004, pp. 116-117.

Cotter, Holland. "Black Comes In Many Shadings", *New York Times*, August 13, 2004, p. E29.

Kelly, Kevin. "Reward for Creative Touch", *Daily Nation* (Lifestyle Magazine), August 11, 2004.

Johnson, Kenneth. "She's Come Undone", *New York Times*, July 9, 2004.

Ribas, Joao. "She's Come Undone", *Time Out New York*, July 8, 2004 p. 55.

Saltz, Jerry. "Borough Hall", *Village Voice*, May 3, 2004.

Smith, Roberta. "Emerging Talent and Plenty of It", *The New York Times*, March 12, 2004.

Martin, Courtney. "Looking Both Ways", *Flash Art*, January/February 2004.

Graham-Dixon, Andrew. "All Stuck and Scribbled", *The Sunday Telegraph*, U.K. December 19, 2004, p. 112.

Cripps, Charlotte. "Work at the Cutting Edge", *The Independent Review*, December 2, 2004, p. 18.

Muhammad, Erika Dalya. Exhibition Catalog essay, The Studio Museum in Harlem, July 2004.

Africa Remix, Kunstpalast Duesseldorf, Germany, 2004.

2003

Borgatti, Jean M., and Brilliant, Richard, eds. *Looking Both Ways: Art of the Contemporary African Diaspora*, Exhibition Catalog, 2003.

Williamson, Sue. "Looking Both Ways", *Artthrob*, December 2003.

Sirmans, Franklin. "Portfolio", *Grand Street*, Fall 2003.

Cotter, Holland. "Redefining the African Diaspora", *New York Times*, November 21, 2003.

Pagel, David. "Harrowing, Hallucinatory Visions", *Los Angeles Times*, October 24, 2003.

Firstenberg, Laurie. "Perverse Anthropology", catalog for "Looking Both Ways", 2003.

Koirala, Snigdha. "Black President", *BOMB*, Fall 2003, p. 17.

Ashford, Doug. "Off The Record", *Time Out New York*, May 8 – 15, 2003.

Cotter, Holland. "Off The Record", *New York Times*, May 16, 2003.

Murray, Soraya. "Africaine", *Nka Journal of Contemporary African Art*, Fall/Winter 2002, pp. 88-93.

Schoonmaker, Trevor. *Black President: The Art and Legacy of Fela Anikulapo-Kuti*, The New Museum, 2003.

2002

Murray, Sonya. "Africaine", *Nka Journal of Contemporary African Art*, 2002.

Barliant, Claire. "Africaine", *Art on Paper*, July/Aug 2002.

Banai, Nuit. "Body of Evidence", *One World*, Aug/Sep 2002, pp. 124-125.

Hazlewood, Carl. "Hot Shows From the Edge: Summer in the City", *nyarts*, September 2002.

Johnson, Ken. "Art Guide", *New York Times*, July 5, 2002.

Cotter, Holland. "From the Ferment of Liberation Comes a Revolution in African Art", *New York Times*, Feb 17, 2002.

Cunningham, Bill. "Old and New", Style Section, *New York Times*, Jan 27, 2002.

2001

"African Art Exhibit", *Daily News*, November 25, 2001.

Sonkin, Rebecca. "Good Rap", *Art News*, April 2001, p. 41.

2000

Ziolkowski, Thad. "The Magic City", *ARTFORUM*, October 2000.

Johnson, Ken. "The Magic City", *New York Times*, August 11, 2000.

"The Magic City", *The New Yorker*, August 14, 2000, p. 14.

Johnson, Ken. "The Magic City", *New York Times*, August 4, 2000.

Brockington, Horace. "After Representation", *The International Review of African American Art*, p. 47.

1999

Sirmans, Franklin. "Surely It Cannot Burn So Long", *Time Out New York*, Nov 25-Dec 2, 1999.

Oguibe, Olu, and Enwezor, Okwui. *Reading the Contemporary: African Art from Theory to the Marketplace*, The MIT Press, p. 10.

1998

Sadao, Amy. "Transgressive Imaginations", essay and interview on Wangechi Mutu and Rina Banerjee. 1998.

1997

Jones, Kellie. "Life's Little Necessities", *Installations by Women in the 1990s*, catalogue for the 2nd Johannesburg Biennale, "Trade Routes: History and Geography", p. 287.

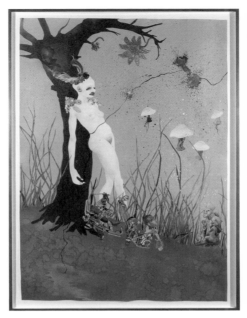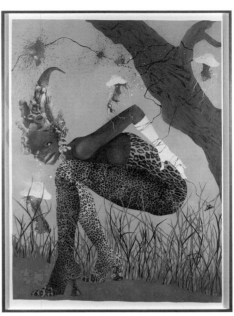

People in Glass Towers Should Not Imagine Us, 2003 mixed media collage on paper, diptych; each panel 70" x 51"

ACKNOWLEDGEMENTS

I give thanks to the grand creator and that which enables our expression, creativity, love and humanity. I'm so thankful to my dear Maitu and Father who've stood by me even when they weren't quite sure how to.

This project began like most beautiful, memorable conversations, quite accidentally. So I feel so privileged for being able to share the experience with such a talented, inspirational and indefatigable team.

I'm so thankful to Wendy Dembo for getting the ball rolling. Thanks to Karen Hsu and the Omnivore family, Douglas Singleton our editor, Tarra Cunningham for steering the project, Karen Del Aguila for her tireless assistance and Yoon Cho for working with us. I am sincerely grateful to the superb writing from the scholars Michael Veal, Isolde Brielmaier, Malik Gaines & Alexandro Segade, and so appreciate the brilliant text from Christine Kim, Kellie Jones, Guillermo Brown and Jyoti Argade. Thanks to Kathryn Parker Almanas for her photography.

Thanks to Susanne Vielmetter, Sikkema Jenkins & Co. for facilitating the process. And finally but in no way the least, an unequivocal thanks to Andrea Albertini, Marcella Manni and the incredible folks of the Damiani publishing house who've been such a pleasure to work with. Love and divine funk to one and all goats! Thank you all indeed!

— WANGECHI MUTU

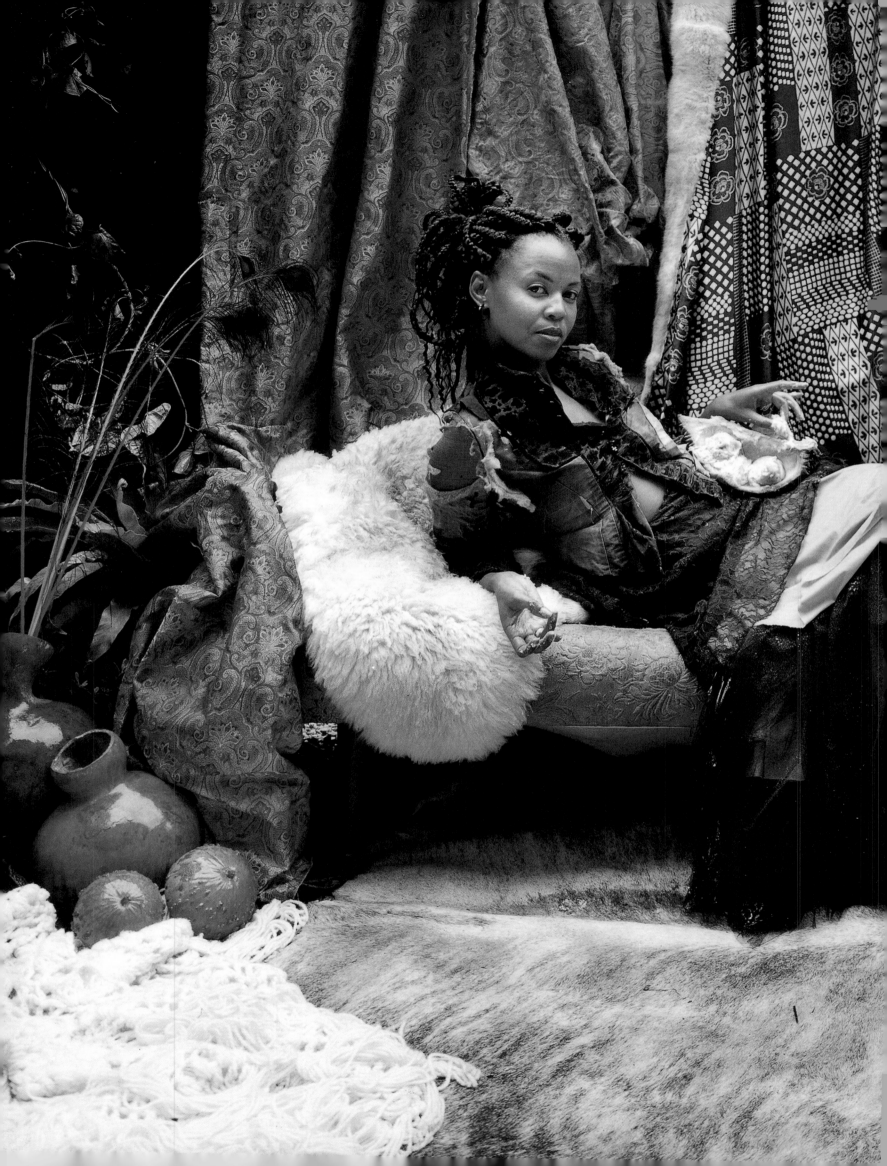